# ASSEMBLED

## TRANSFORM EVERYDAY OBJECTS INTO ROBOTS!

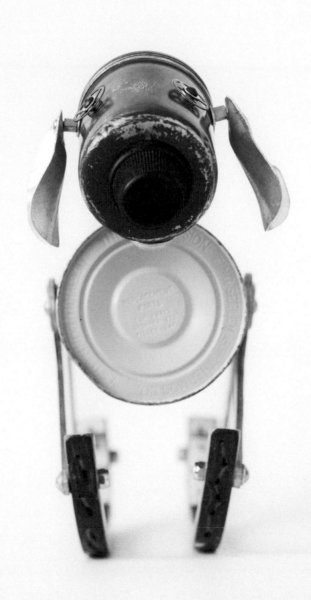

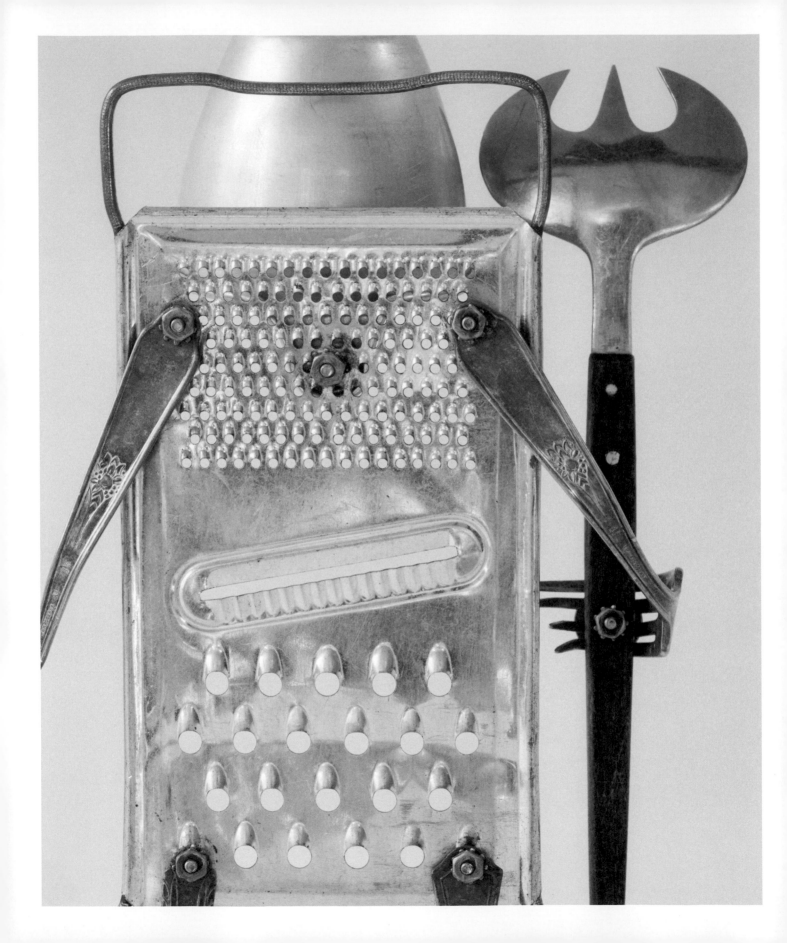

# ASSEMBLED

## TRANSFORM EVERYDAY OBJECTS INTO ROBOTS!

jacqui
small

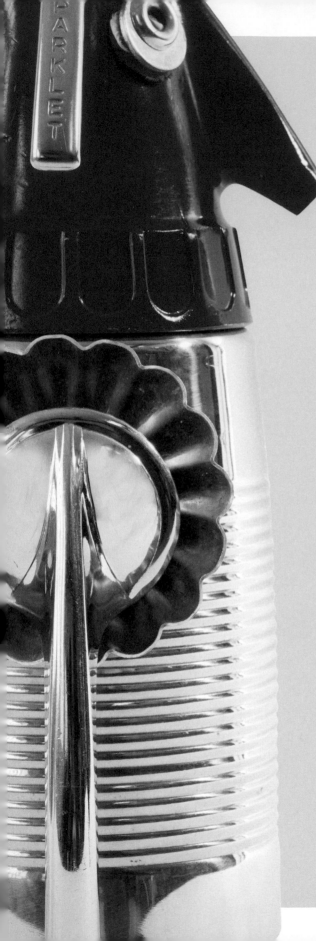

First published in 2017 by
Jacqui Small
An imprint of The Quarto Group

Text, photography, design and layout copyright © 2017 Jacqui Small
Specially commissioned photography by Brent Darby

The authors' moral rights have been asserted.

Publisher: Jacqui Small
Senior Commissioning Editor, Styling and Art Direction: Eszter Karpati
Managing Editor: Emma Heyworth-Dunn
Picture Research and Artist Liaison: Sarah Smithies
Editor: Becky Miles
Designer: Manisha Patel
Assistant Editor: Joe Hallsworth
Production: Maeve Healy

Front and back cover: *Cheese Guardian* by Branimir Misic

ISBN: 978-1-910254-54-7

A catalogue record for this book is available from the British Library.

2019 2018 2017
10 9 8 7 6 5 4 3 2 1

Printed in China

Quarto is the authority on a wide range of topics.

Quarto educates, entertains and enriches the lives of
our readers – enthusiasts and lovers of hands-on living.

www.QuartoKnows.com

# CONTENTS

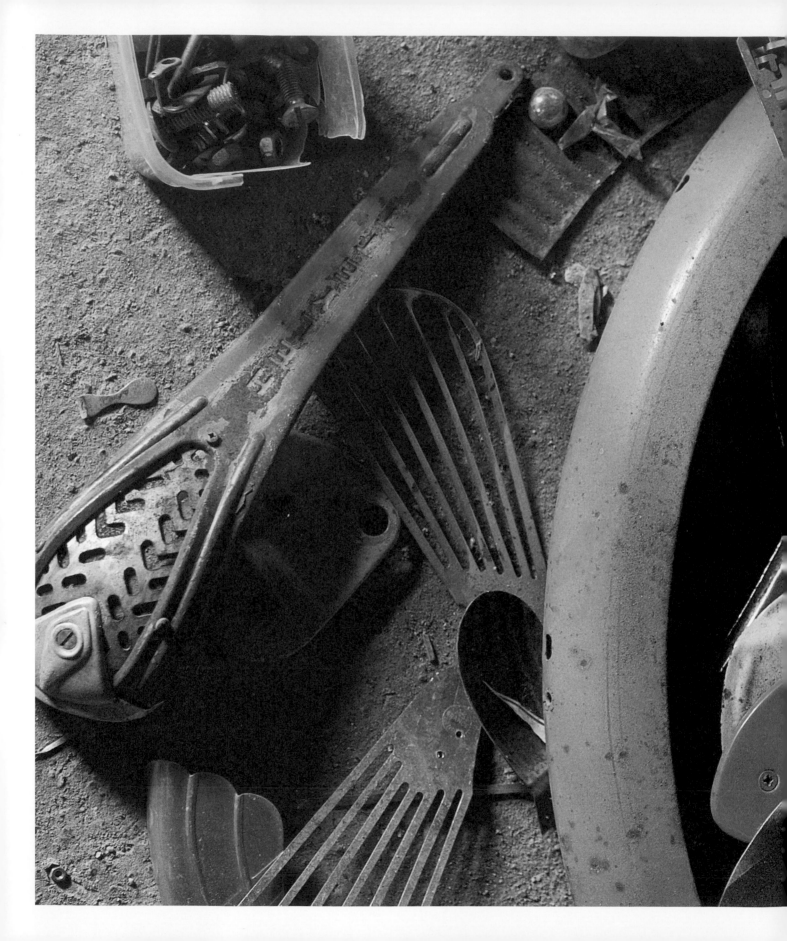

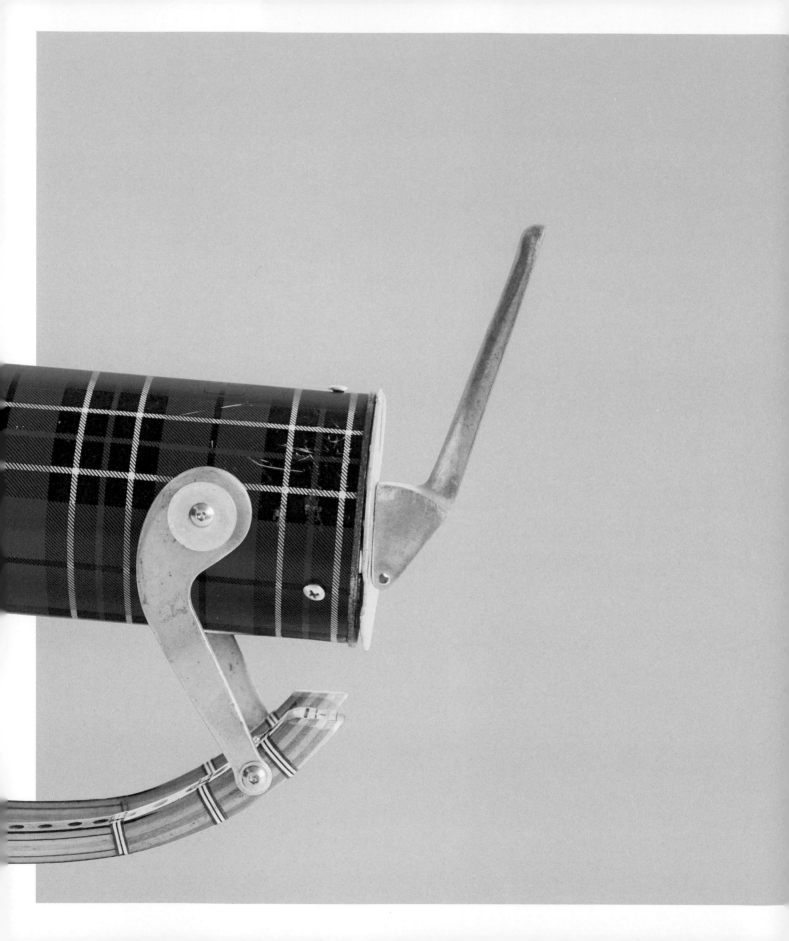

# ASSEMBLE!

## WHY AND HOW

"Random flea-market finds, old spatulas, rusty forks and spoons – really, anything could be a potential robot ingredient. Cutlery is particularly good for creating arms and legs; you can even bend the tines of a fork individually to allow your robot to gesticulate."

For many of us, going to flea markets has something of a magical quality; we are drawn to the atmosphere, we like to go regularly, we browse around – it always feels as though we are on the hunt for something specific but we don't quite know what that particular thing looks like. And that thing could be anything – an enamel strainer, a silver cigarette case, an old postcard – we just don't know until we see it, so we carry on looking for it until we find it.

The pleasure is clearly as much in the searching as it is in the finding. For me, it might take a handful of visits to a flea market or my favourite second-hand (thrift) stores before I finally spot that perfect object... I did not know I needed that beautiful faded green turn-of-the-century chocolate tin up until this point in my life, but now that I have found it, I just have to have it.

"Tool boxes and workshops might house some real gems for your robot projects – have a good look around and see if you can spot any bits and pieces that spark your imagination. Use a cardboard box to gather together all the parts that you like the look and feel of."

This love of the flea market experience is often where the robot-making journey begins. All of the wonderful things you come across on the market stalls suddenly gain a reason for being – and a fully legitimised excuse for buying; you are now moving beyond what might be seen as self-indulgent junk collecting, and are starting to work towards the noble pursuit of assembling your own robot. And once you have found that all-important key ingredient, the rest will follow naturally. It may take a while to find the perfect companion parts to the essence of your robot but, again, the joy is in the search, and you will doubtless find things that could form parts of other robots along the way. It can be tricky to source matching objects – for arms, legs, hands or eyes, for example – but it can add charm to use mismatched items. Alternatively, consider dismantling or splitting parts in two to achieve symmetry.

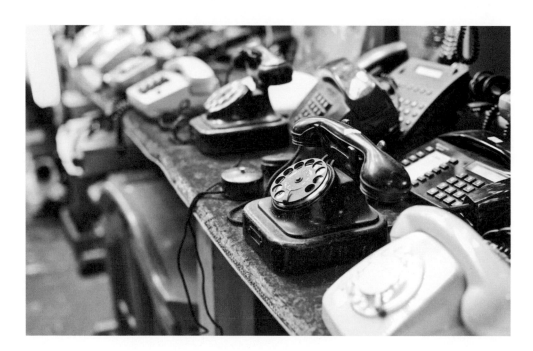

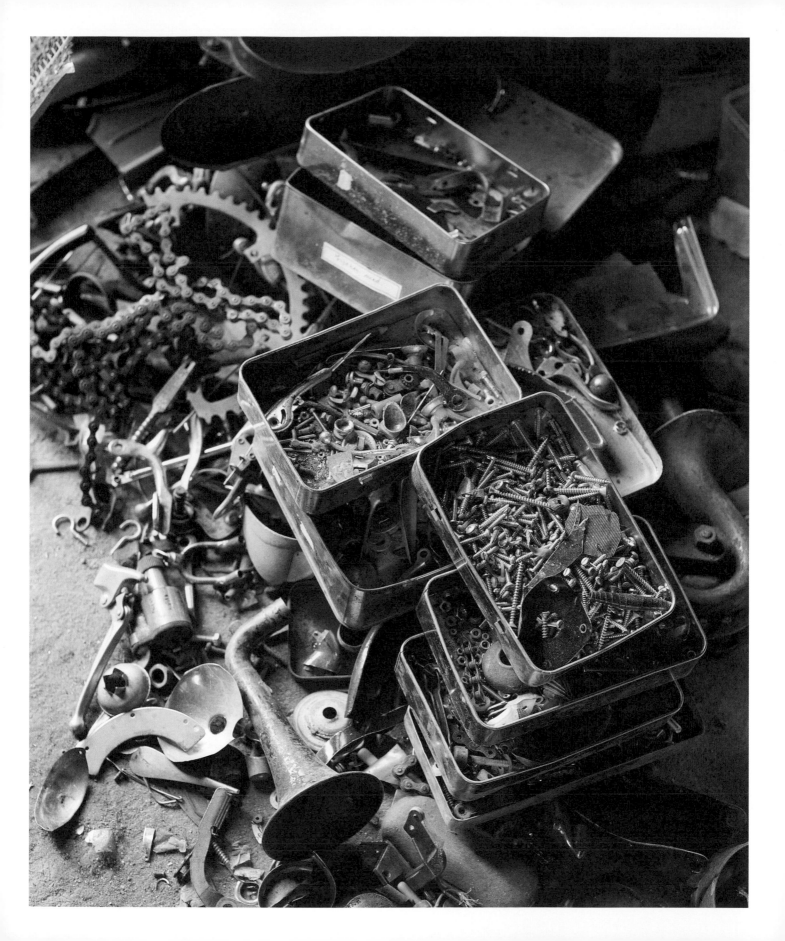

"Always look out for ingredients that could be useful for your robot project. Old bikes and tin boxes can make very beautiful bot parts; over time, the paint tends to chip off and they develop a patina which will add plenty of charm and character to your final piece."

Assembling the robots in this book is not unlike following a recipe so we decided to model the style of the projects loosely on recipes in a cookbook. As each of the robot projects is made of found objects, the ingredients relate to each specific bot recipe but you can easily substitute other found objects made of the same or similar materials. What's so wonderful about making a robot is that the end result will always be completely unique – in the specific parts used, their age, style and colouring, and the bonding and assembly techniques employed; all of which contribute to their own distinct characters and personalities. No two robots are ever the same.

Eszter Karpati
Editor

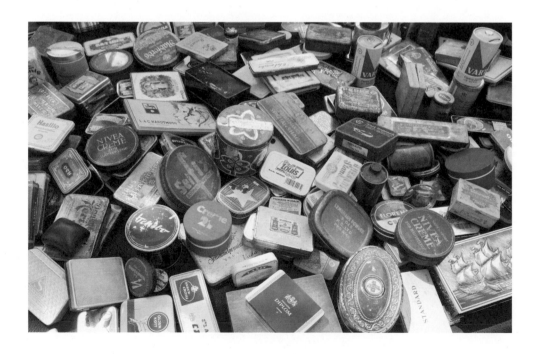

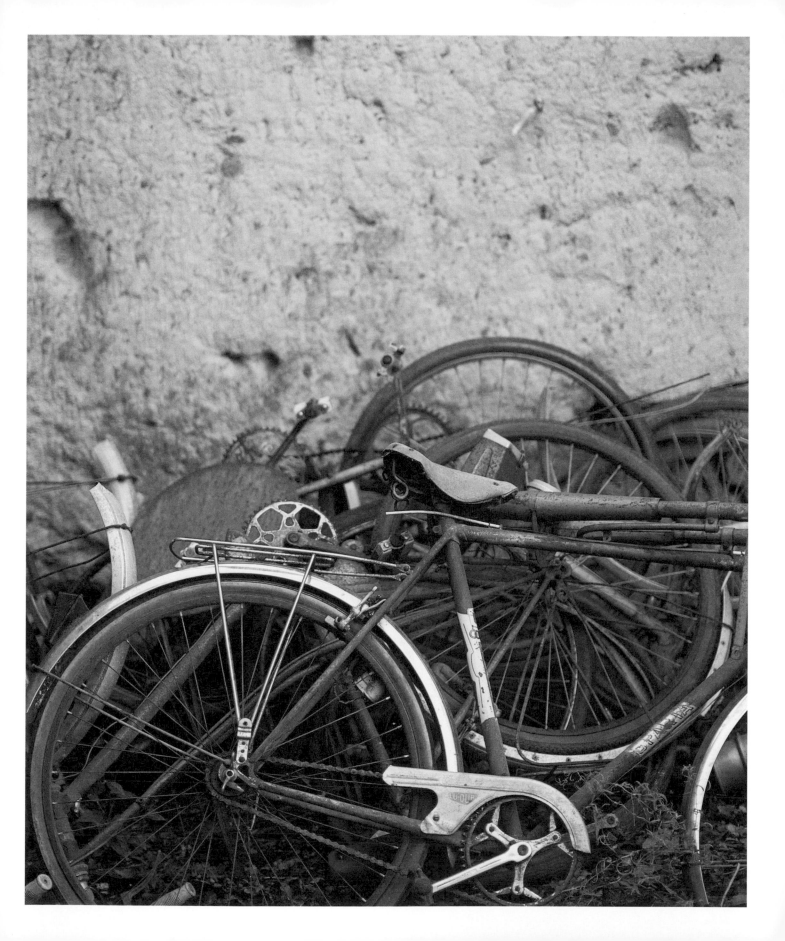

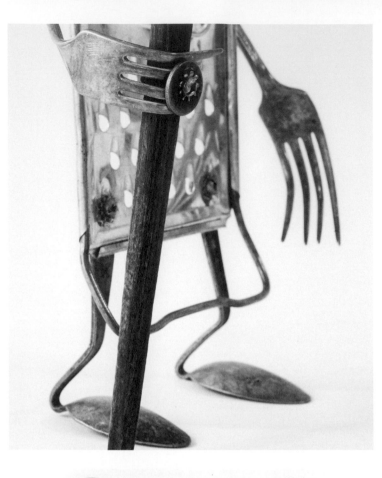

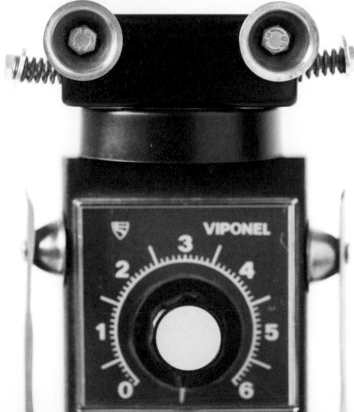

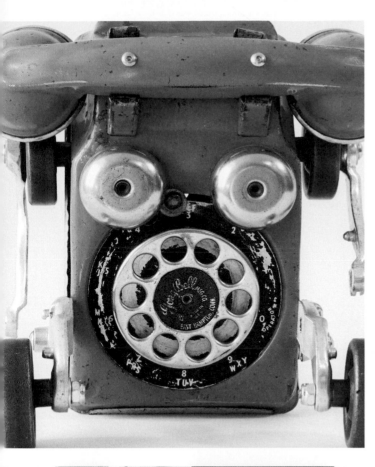
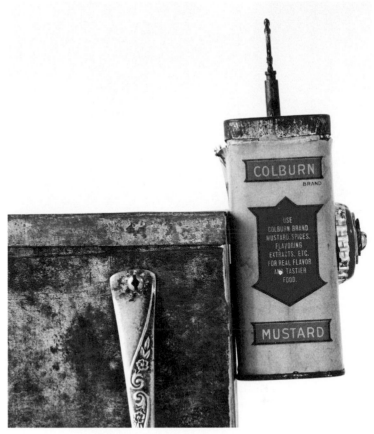
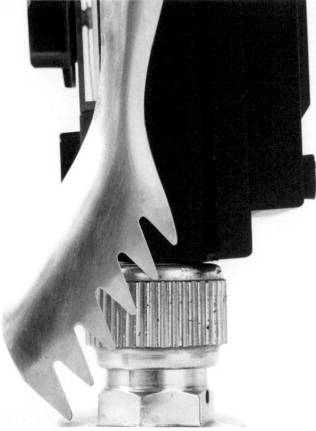
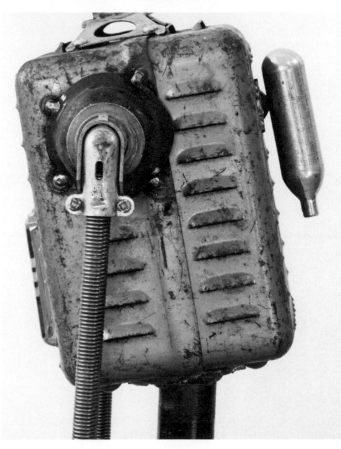

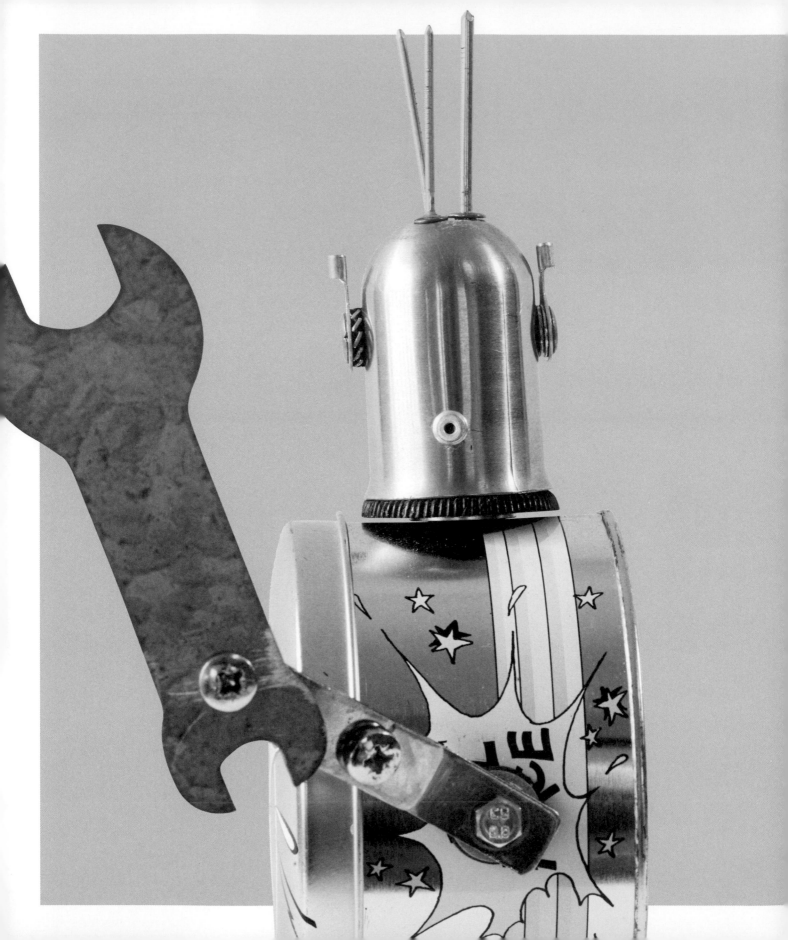

# ROBOTS

## BEFORE AND AFTER

"Each robot project is shown two ways: disassembled first, assembled second. Have fun working out how these selections of seemingly unrelated objects got transformed into robots. Read the recipes, learn all about the various methods and be inspired to make your own."

The robot recipes in this section have been devised by an incredibly creative and imaginative group of contributing robot-makers. Using found objects and various other ingredients, they talk you through the methods they employed to transform their collections of found objects into robots. They also share the inspirations behind their work and describe a little of the personality of each piece. The robot recipes are organised into four main themes, each based around a key ingredient used in their creation: containers, kitchen utensils, objects used for leisure or sports, and scrapyard junk. Each themed section starts with some bots that are easier to make and require simpler tools, and then works towards more complex robot creations. All of the projects have a "spanner rating" of 1, 2 or 3 spanners, relating to their level of complexity, but all are equally inspiring.

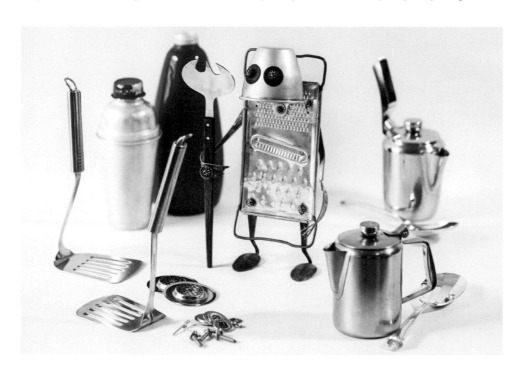

# TINS AND CANS

A discarded tobacco can or an old toffee tin can be a great starting point for your robot project; these vintage containers don't just age beautifully, they are also large enough to form the core body part of your bot and are usually made of metal thin enough that you can drill through them with ease. In fact, you often don't even need to use a power tool, but can simply pierce through the material with a screwdriver and fix the limbs or eyes into position with some nuts and bolts, hidden on the inside, if you wish.

If you prefer non-chemical bonding techniques, working with metal containers is a great route; you can seamlessly conceal anything that has little or no aesthetic value.

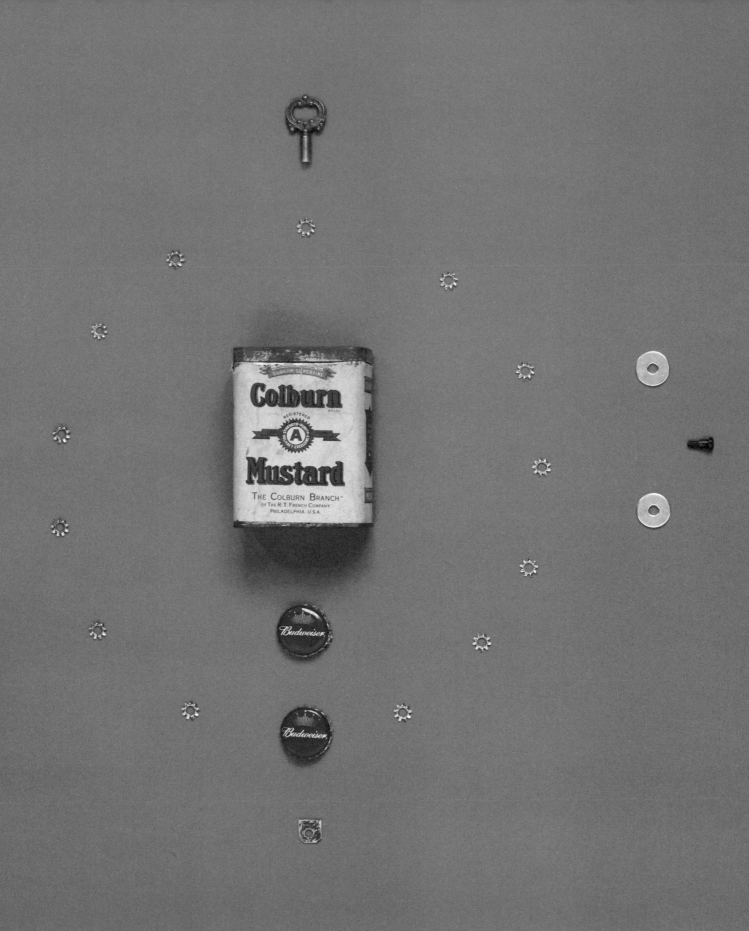

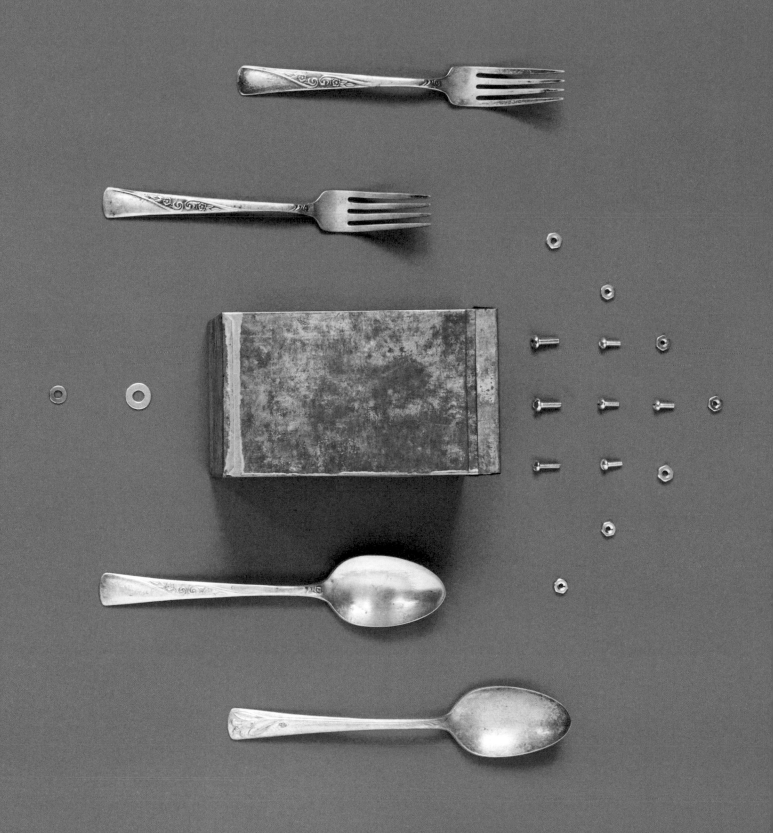

# WAITING FOR YOU

## BRANIMIR MISIC

**SIZE**
18 x 15 cm
(7 x 6 in)

**WEIGHT**
0.4 kg (14 oz)

**COMPONENTS**
2 metal boxes – 1 larger,
  1 smaller
2 antique spoons
2 antique forks
8 bolts
8 nuts
1 antique key
2 beer bottle caps
13 tooth-lock washers
4 plain washers
1 small scrap of metal

**TOOLS**
Drill
Screwdriver
Pliers
Soldering iron

*I had the idea for* Waiting for You *while listening to the Otis Redding classic, "Sittin' on the Dock of the Bay". I wanted to build a small humanoid piece that would be just sitting and waiting for its buyer. I found the parts I needed at antique markets and my local hardware stores and put it all together quite quickly. The piece is built to appear sad, as if it is waiting for a loved one to return. At the same time, to me, its antique components give it extra layers of character and history, as if it has a deeper understanding of life.*

### [ METHOD ]

Gather together all of your found pieces and start by making the head of this fairly simple piece. First, drill two holes in the front of the metal mustard box and bolt on the beer bottle cap eyes, adding washers and any suitable scraps of metal as desired to build them up. Next, make a hole in the top of the box, partly insert the antique key and solder it in place.

Take the larger metal box and drill holes at the top and bottom of each side. Then, drill holes at the top of each spoon and fork handle, in order to bolt these onto the metal box body as its legs and arms. Before fixing the limbs to the body, twist the spoon legs so that the piece looks like it is sitting down, and bend the fork arms and tines so that they form expressive arms, hands and fingers that appear to be resting on the legs.

Finally, take the completed head and bolt it to the front of the completed body, adjusting it to create the most harmonious positioning of the two pieces. Total assembly time for the little bot should be around 1 hour.

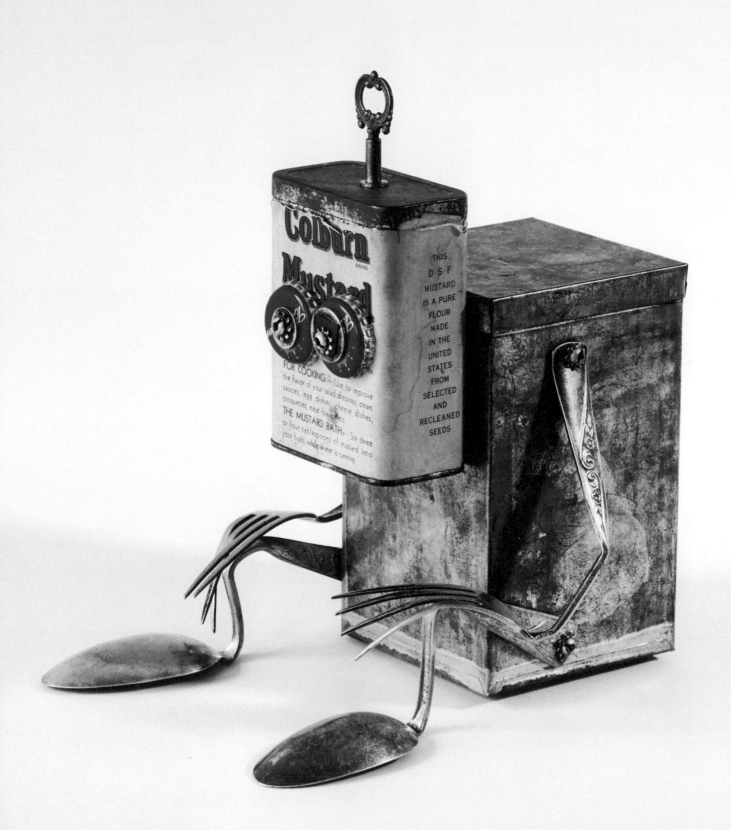

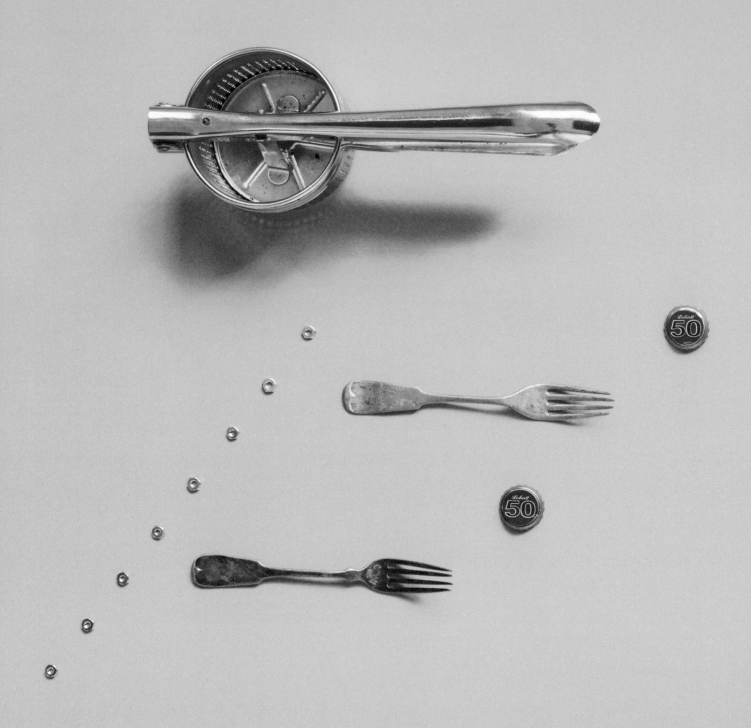

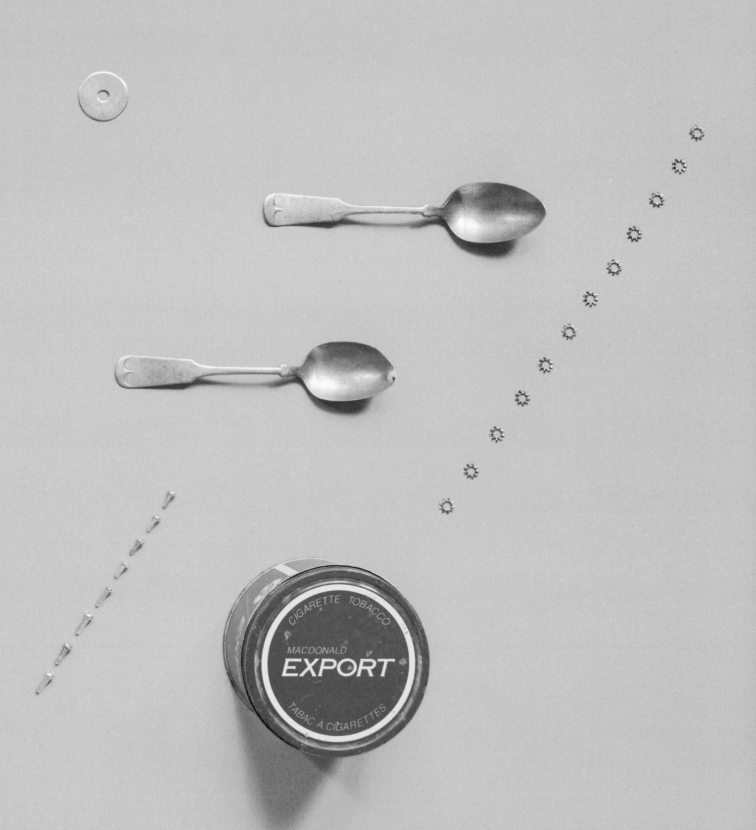

# I AM NOT CRAZY

## BRANIMIR MISIC

**SIZE**
30 x 20 cm
(12 x 8 in)

**WEIGHT**
0.8 kg (1 lb 12 oz)

**COMPONENTS**
1 potato ricer
1 metal tobacco tin
2 spoons
2 forks
2 beer bottle caps
8 bolts
8 nuts
12 tooth-lock washers
1 plain washer

**TOOLS**
Drill
Screwdriver
Pliers

*I Am Not Crazy was inspired by the discovery of an old potato ricer at an antique market. I picked it up and thought it looked like the beak of a crazy duck. This led me directly to the name of the piece, and the rest of its parts and character developed from there. I twisted the forks used for the arms to give him somewhat accusatory hand gestures, as though he is perhaps accusing someone of eating his favourite pie.*

## [ METHOD ]

Once you have chosen and gathered together all of your pieces, start by making two holes in the potato ricer head for the eyes. These are made by bolting beer bottle caps and a couple of washers onto the head.

Next, take the tobacco tin body and figure out how best to position the arms and legs of your piece to your taste. Drill holes as appropriate and bolt on the forks as arms and the spoons as legs. Bend the spoons to form feet, ensuring that the piece is stable when freestanding – this can be a little tricky as the potato ricer head is quite heavy – and then bend the tines of the forks to give him characterful hand gestures.

Lastly, use nuts, bolts and washers as appropriate to fix the potato ricer head to the tobacco tin body, adjusting the precise position of the head to give the little guy that slightly puzzled air. With a bit of preplanning and enough nuts, bolts and washers to hand, the piece should take around 1.5 hours to complete.

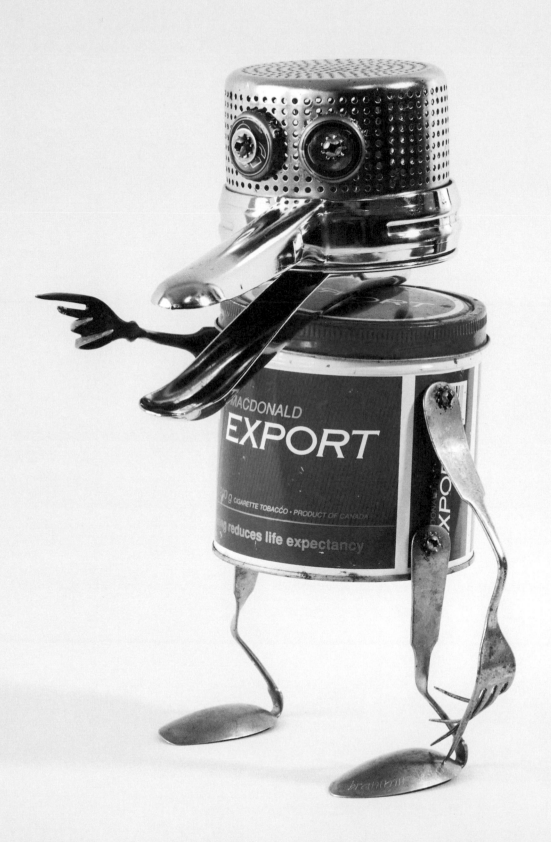

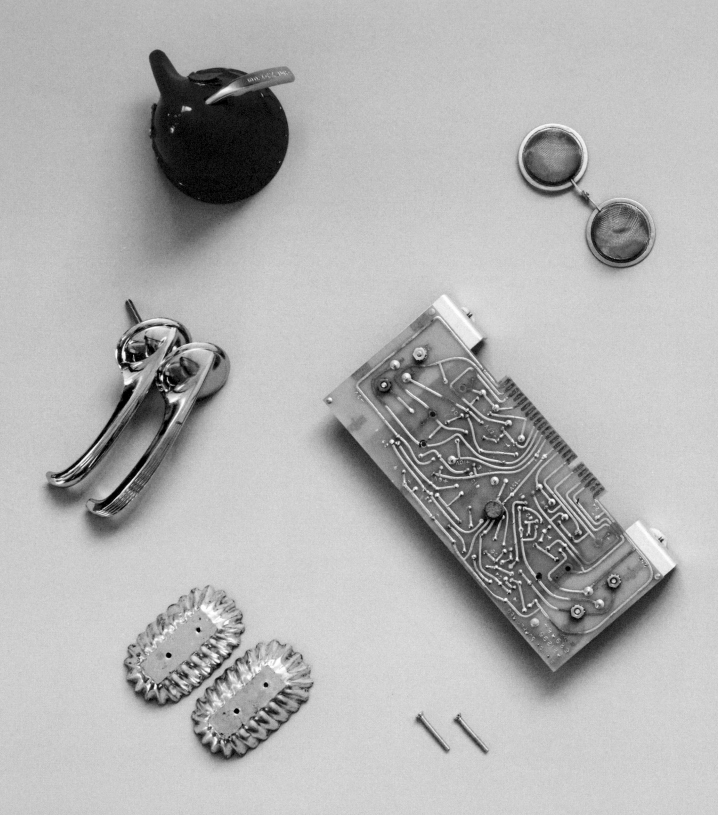

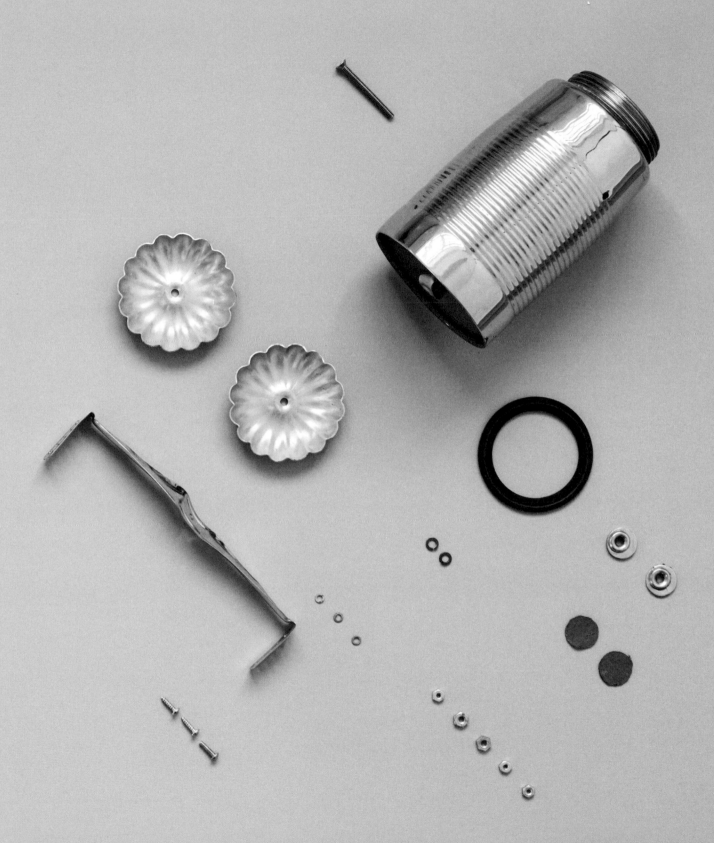

# ROCKET MAN

## AMY KNUTSON

**SIZE**
32 x 23 cm
(12½ x 9 in)

**WEIGHT**
1 kg (2 lb 3 oz)

**COMPONENTS**
1 "Sparklet" vintage soda
siphon, dismantled

1 black rubber seal

1 tea infuser ball, halved

2 old car door handles

2 small round fluted tart
tins

2 small rectangular fluted
tart tins

1 small pair of tongs

1 old circuit board (if
desired)

6 assorted screws and
bolts

5 assorted washers

5 small nuts

2 small rubber circles

2 small leather circular
patches with eyelets

**TOOLS**
Screwdriver

Drill

Epoxy glue

*Rocket Man started with the soda siphon, which I first thought would make a good rocket, but then began to look more like a rocket "man" to me. He sat on my bench for a few months, while I slowly collected the other parts. The car-handle arms, found in a local vintage store, were just the right kind of macho, and the tart tins reminded me of articulated sections of space suits I had seen in mid-century pictures of astronauts. His goggles and base were a late addition, found in my husband's pile of things he "might use some day". I think Rocket Man is posing for a press photo, extremely proud and excited. He knows he has the "right stuff".*

### [ METHOD ]

Starting with his head, *Rocket Man* is assembled by taking the head of a vintage "Sparklet" soda siphon and screwing or gluing the rubber circles and circular patches with eyelets into it for his eyes. Next, glue on the tea infuser ball halves for his space goggles.

Then, fix his car-door-handle arms to the soda siphon "body" by first gluing the head of a bolt into the opening of each handle and letting it set. Then, drill holes into the fluted tart tins that are his shoulder pads and thread them onto the bolts before drilling holes in the body and pushing the bolts through them, using washers and nuts inside to fix securely.

The legs are made from mini tart tins screwed to a small pair of tongs that are bent at right angles at the bottom, and then stretched out to give him his manly stance. Bolt them to the bottom of the body. Note: you may need to fix a strip of metal to the bottom of the body cavity in order to attach this bolt depending on the construction of your soda siphon.

Once the body is complete, simply screw the siphon lid back on top, making use of the rubber seal. If you would like to place *Rocket Man* on a stand, I suggest an old circuit board to complete his high tech, yet retro, appearance. Expect the whole construction process to take around 2–3 hours, over a couple of days, to allow for glue drying time and any custom adjustments you may need to make.

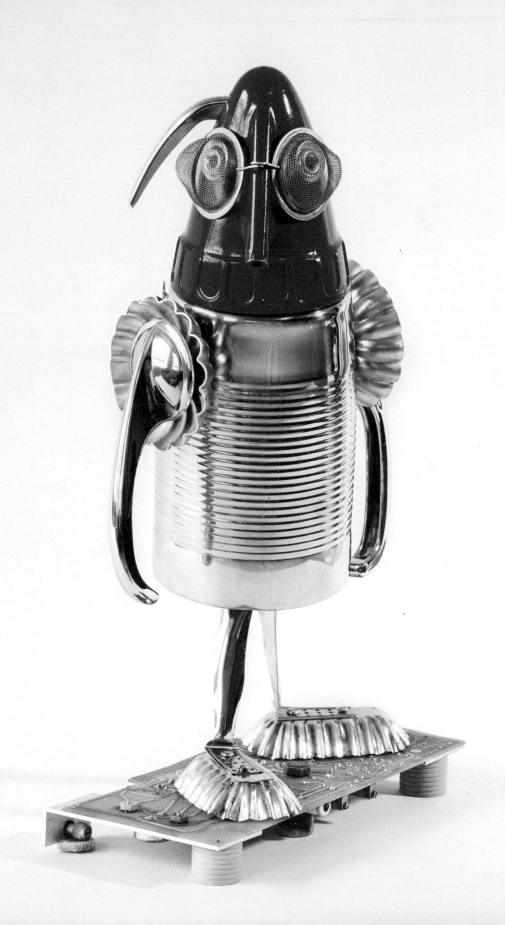

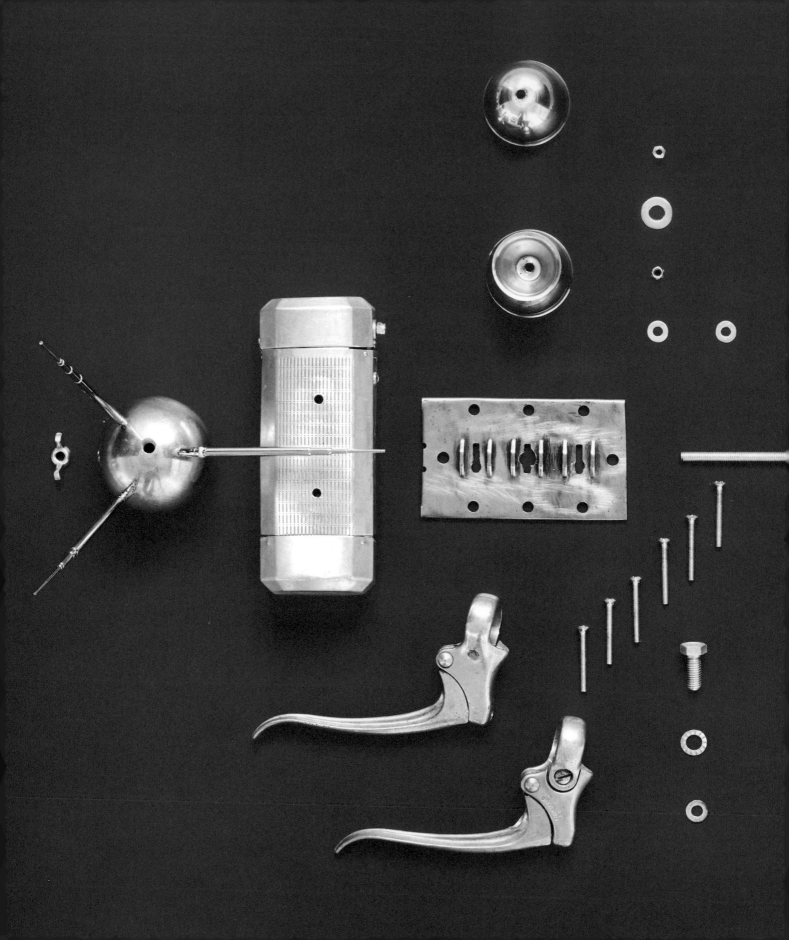

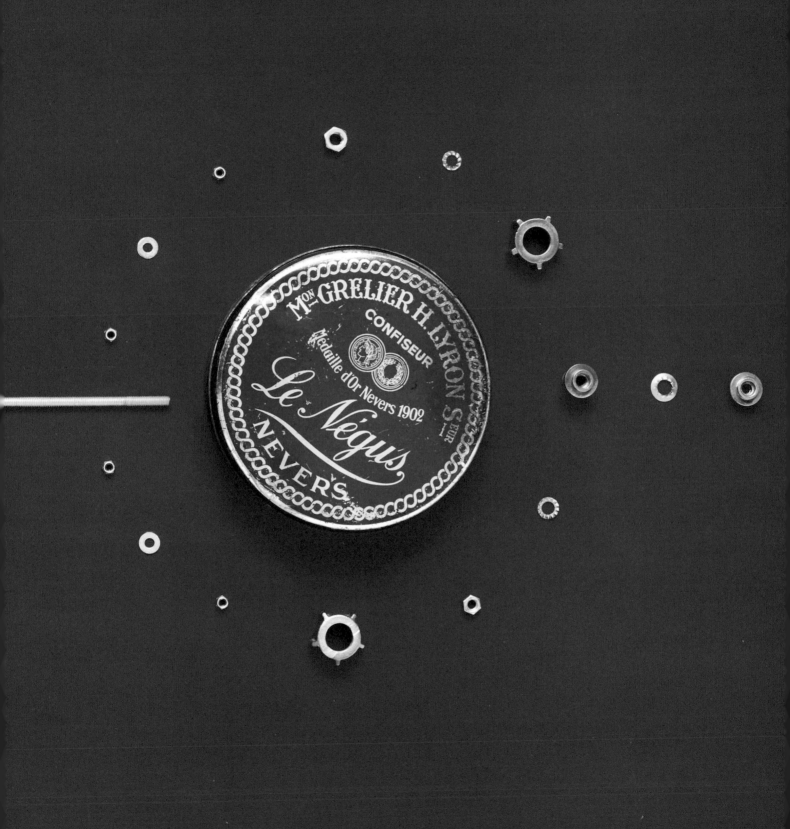

# NEGUS

## GILLE MONTE RUICI

**SIZE**
35 x 28 cm
(13¾ x 11 in)

**WEIGHT**
0.8 kg (1 lb 12 oz)

**COMPONENTS**
1 metal tin

1 small metal plate

2 metal egg cups

2 bicycle brake handles

1 metal glasses case

2 large nuts

1 metal ball with antennae

1 metal baton or skewer
  (approx. 15 cm/6 in long)

10 nuts

10 assorted washers

7 screws

1 wing nut

**TOOLS**
Drill

Screwdriver

Wrench

*This bot holds great sentimental value for me. Negus is a soft chocolate caramel made in the town of Nevers in Burgundy, France. I was born in Nevers, so it's very much a nod to my own origins. When I spied this metal tin, which used to contain the sweets, in a flea market, I bought it straight away. The two bicycle brake handles I have used as arms give Negus a questioning air, but he is nevertheless quite self-assured. The tin of sweets is a commemorative one, made in honour of an official visit to Nevers in 1902 by the ruler of Ethiopia, the Negus, after whom the sweets and the bot are named.*

## [ METHOD ]

People keep metal tins for practical, sentimental or aesthetic reasons. The tin making up the body of this particular robot is a combination of all three. It forms the central part of the bot, with all of the other pieces screwed or bolted onto it.

To give the bot a stable base, bolt it to a small metal plate onto which two inverted metal eggcups are themselves screwed. For the arms, use two bicycle brake handles screwed to the sides of the tin. For the head, take a metal glasses case and screw on two large brass bolts for the eyes.

*Negus'* stylish hairdo is created with a mysterious metal ball with three antennae sticking out of it that I found in the trash. If anyone has an idea what this was in a former life, I would love to know! Drill a hole in the top of the ball, the top and bottom of the glasses case, and the top of the tin body. Then take a metal baton or skewer and thread it through all of these pieces, fixing with a wing nut at the top and suitably sized nut at the bottom (within the tin).

The whole piece can be assembled with screws and bolts in an hour or two – no welding required. Raw materials such as these are pretty easy to find, making the creation of a curious and confident little bot such as *Negus* well within the reach of us all.

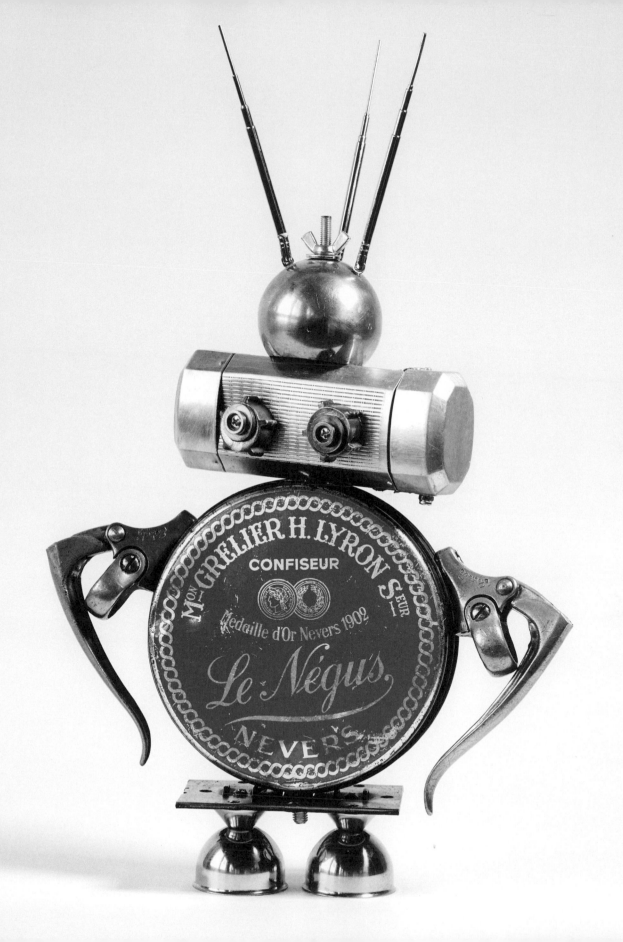

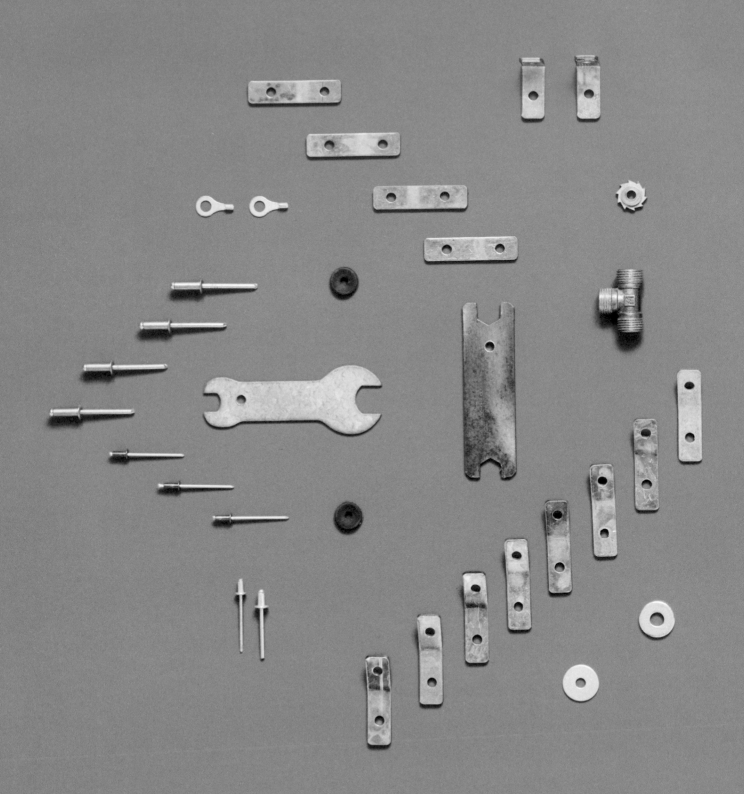

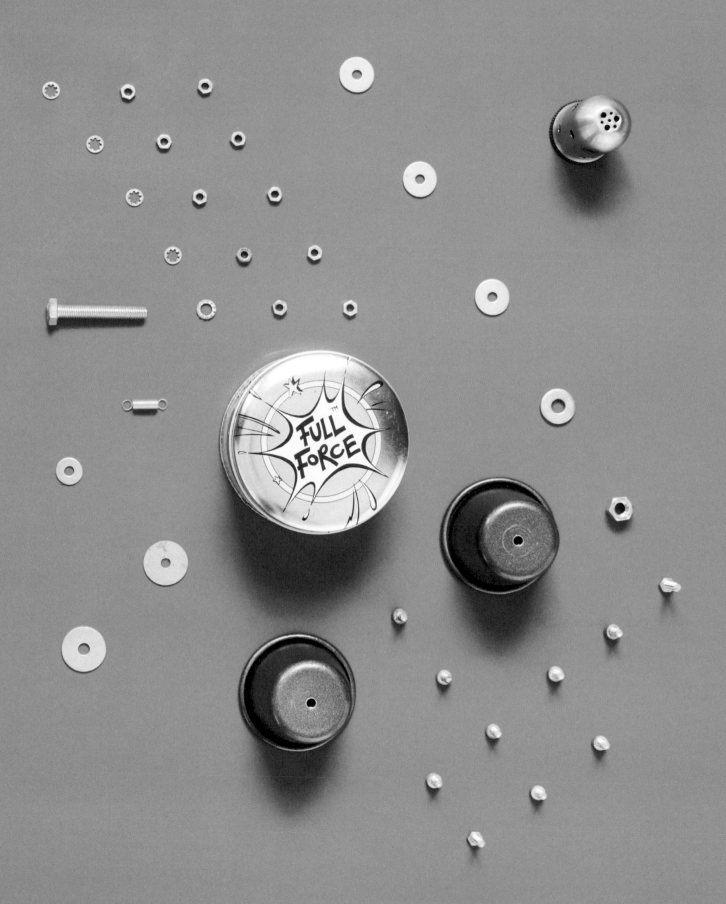

# JUPITER

## PAUL BRADY

**SIZE**
36 x 16 cm
(14 x 6¼ in)

**WEIGHT**
0.6 kg (1 lb 5 oz)

**COMPONENTS**
1 round metal tin

2 small pudding tins

1 salt shaker

2 old spanners (wrenches)

14 pre-drilled flat metal
bars

17 assorted washers

10 small nuts and bolts

1 larger nut and bolt

1 small spring

1 small T-shaped
compression joint

2 electrical connectors

9 assorted pop rivets

**TOOLS**
Hammer

Vice

Socket wrench

Blowtorch or soldering iron

*Jupiter was inspired by a comic book character from a story that was first run back in the 1980s. I recently reread the story when looking for a new robot to build. At the same time, the "Full Force" tin (which used to contain mints) had been sitting on my desk for months, and I'd been thinking about how I should use it in one of my robots... And then it came to me, while reading about the comic characters in action. Once I had my idea, I just needed to gather the other parts from the usual flea markets, junk shops and hardware stores. And the result is this cheerful, dependable companion.*

## [ METHOD ]

First, take the round tin body and pudding tin feet and start by building some legs to link them together. Use 10 of the pre-drilled flat metal bars, two of which you will need to bend into right angles using a hammer and a vice, and fix them together with some washers, nuts and bolts. Drill a hole in the bottom of each pudding tin and bolt the legs into the feet, using a socket wrench.

Next, make the arms. Two flat spanners look suitably strong and powerful and are joined to the side of the body with the remaining flat metal bars – bent slightly to bring the arms away from the body – fixed with washers, nuts and bolts.

To attach the legs to the body, first take the T-shaped compression joint, slide a bolt through it and the top metal bar on each leg, and tightly screw a corresponding nut to hold the legs together. Next, weld or solder another bolt into the middle part of the T-joint and drill a hole into the base of the tin. Push this bolt into the body and fix in place with a couple of washers and a locking nut.

Finally, work on the head, which will bring the robot to life. For *Jupiter*, I used an old salt shaker with some pop rivets for antennae, washers and rivets for eyes, two small electrical connectors for ears and a small spring for his mouth. The base of the shaker is riveted to the top of the tin body and then the rest of the shaker head is simply pushed back onto the base and secured with one last rivet drilled in the back of the head. I allow up to 4 weeks assembly time, which gives time to disassemble and start over if you aren't quite happy with your bot.

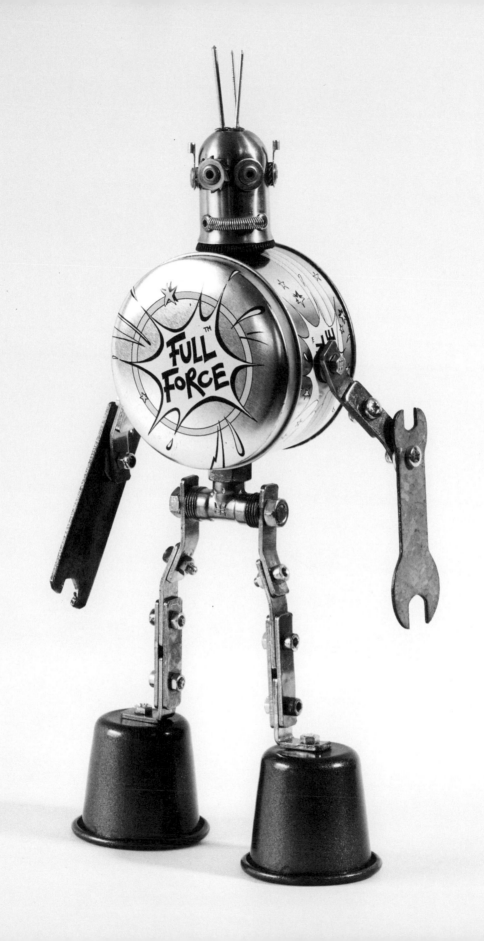

# KITCHENALIA

Don't throw away unwanted items knocking around in the back of your kitchen cupboard – a lemon squeezer, a cheese grater or a rusty copper teapot might all be objects that will trigger an unexpected robot narrative; it's often the everydayness of these products that can create a story around a piece. The more familiar the object, the less expected the transformation!

Knives, forks and spoons are perfect for creating limbs – a couple of silver spoons from an incomplete set is all you need and they don't even need to match. Larger serving spoons or spatulas (turners) are good for holding up heavier constructions. Anything that opens up, such as a garlic press or a small industrial milk jar with an attached lid, will make a great mouth – or a beak – and will lend a charming puppet-like expression to your bot.

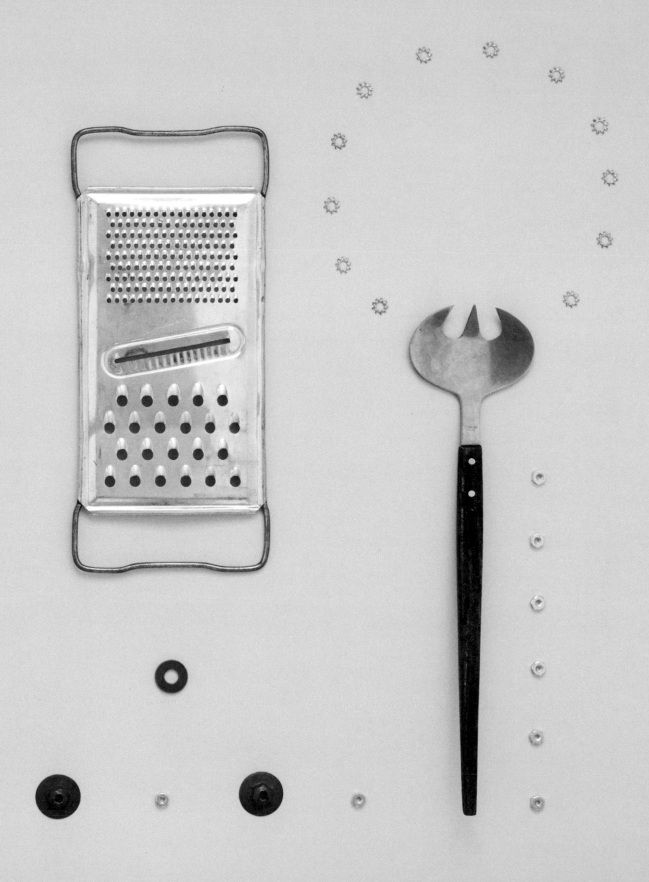

# CHEESE GUARDIAN

## BRANIMIR MISIC

**SIZE**
25 x 13 cm
(10 x 5 in)

**WEIGHT**
0.4 kg (14 oz)

**COMPONENTS**
1 metal measuring cup
1 cheese grater
2 spoons
2 dinner forks
1 salad-server fork
8 bolts
8 nuts
2 metal buttons
12 tooth-lock washers
1 plain washer

**TOOLS**
Drill
Screwdriver
Pliers

*Since a cheese grater's purpose is to end the existence of a block of cheese, I imagined this repurposed cheese grater to be, in its second life, the opposite – a protector of cheese. To this end, I gave him a weapon – a trident – to defend the cheese, and named him suitably as* Cheese Guardian. *His component parts came from the usual antique markets and hardware stores that I visit, and I tried to give him the characteristics of a soldier – stiff and disciplined, standing guard, with weapon ready in hand.*

[ **METHOD** ]

Once you have gathered together your parts and tools, assembly of your *Cheese Guardian* should take around an hour. First, put together the head by drilling two holes in the measuring cup, about halfway down, and bolting on the metal buttons, affixing with nuts, bolts and tooth-lock washers, to make the eyes.

Next, decide where you would like to position the arms and legs on your guardian's cheese-grater body. Drill holes accordingly and use as many nuts, bolts and washers as you need to fix the fork arms and spoon legs to the back of the grater.

Bend the spoons into feet and shape one of the forks into position so it can grip a larger salad-server fork as a trident. Bolt the fork hand to the trident and let the end of the trident rest on the floor – this will provide a useful additional point of stability for the piece.

Finally, screw the head to the top front of the body with a final nut and bolt, and your guardian is ready to protect you and your cheese!

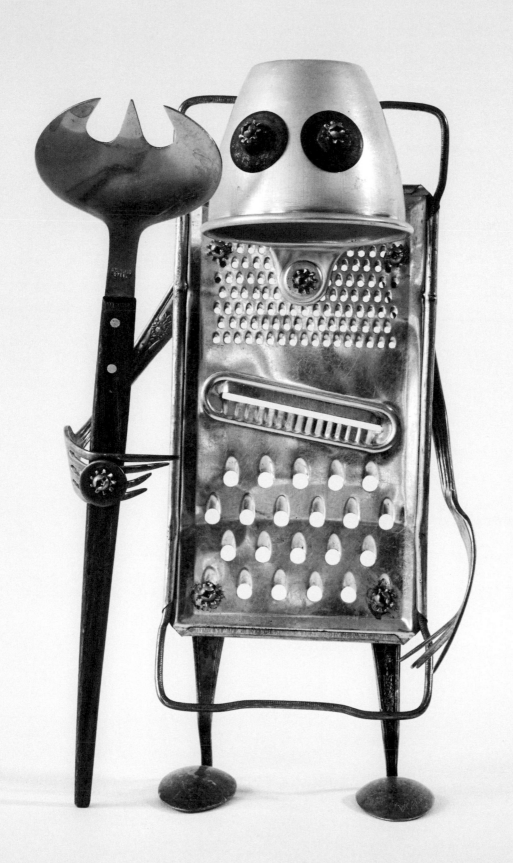

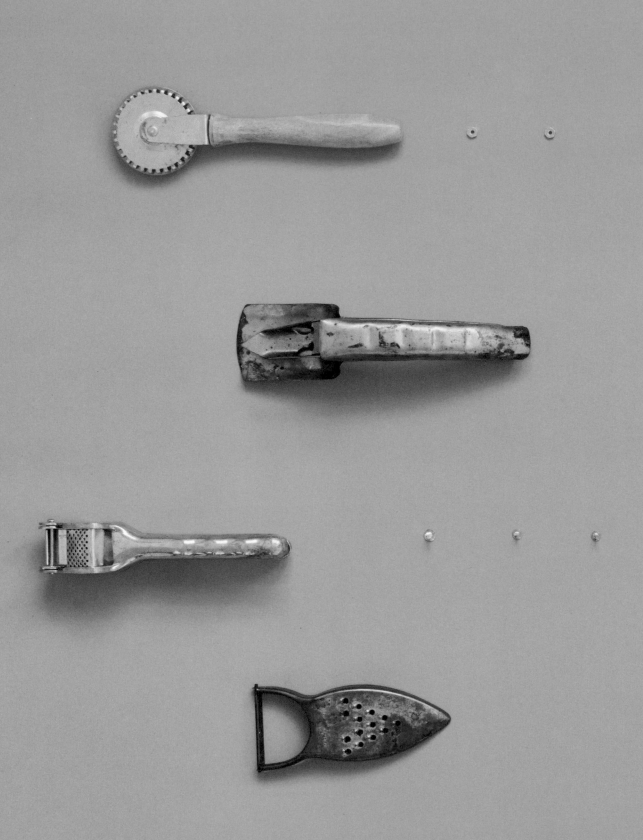

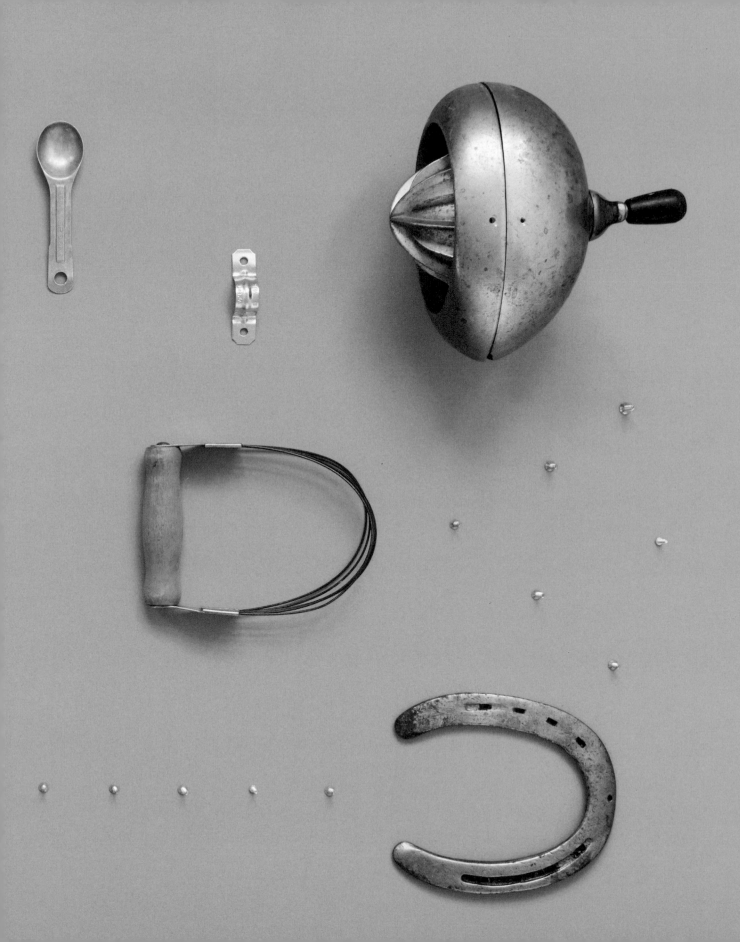

# DUCK, DUCK, JUICE

## DAVID MEAD

**SIZE**
45 x 20 cm
(18 x 8 in)

**WEIGHT**
1.5 kg (3 lb 5 oz)

**COMPONENTS**
1 vintage wall-mount
orange juicer

1 garlic press

1 oil-can spout

1 horseshoe

1 potato peeler

1 vintage pastry sifter

1 pastry/pasta crimper
wheel, halved

1 measuring spoon

1 metal bracket

Assorted nuts, bolts and
screws

**TOOLS**
Drill

Screwdriver

Pliers

*I spotted the juicer that forms the body of* Duck, Duck, Juice *at an antique market and the idea to make a duck immediately popped into my head. A second or two later his name arrived, too. I could think on it for another year and not come up with a more appropriate moniker. My father-in-law loves flea markets, and I was shopping with him when I found the juicer. I tried to explain what I was seeing, and he very kindly (though sceptically) nodded in encouragement. I'm always most excited to show him a final piece because he appreciates – and knows the use of – every original part.*

### [ METHOD ]

Gather together the pieces you've chosen to use. I find that the most time is spent in the searching for parts: a few enjoyable hours here and there at antique markets and flea markets. From the time I found the juicer it took me two weeks to put *Duck, Duck, Juice* together, two evenings of which was the actual handiwork.

To assemble, take the juicer and oil-can spout and position together to form the duck's body and neck. Drill between two and four small holes in one side of the juicer and use nuts and bolts to join the pieces together. Fix the garlic press to the spout to make the bird's long bill in a similar way.

The real personality of this piece comes from the pastry sifter that forms the duck's feathered crown. Fix the two halves of the pastry cutter wheel to one side of the sifter to form the eyes and join the whole thing to the duck's neck. I use nuts and bolts to stick things together but you can use whichever fixing methods you prefer.

Lastly, attach the potato-peeler tail and horseshoe feet to the duck, using the metal bracket and part of the measuring spoon as a support underneath the body. These final pieces will ensure that the bird is stable and well-balanced, and there you have it! A characterful creature, hidden just beneath the surface of these beautifully designed old kitchen items, has been born.

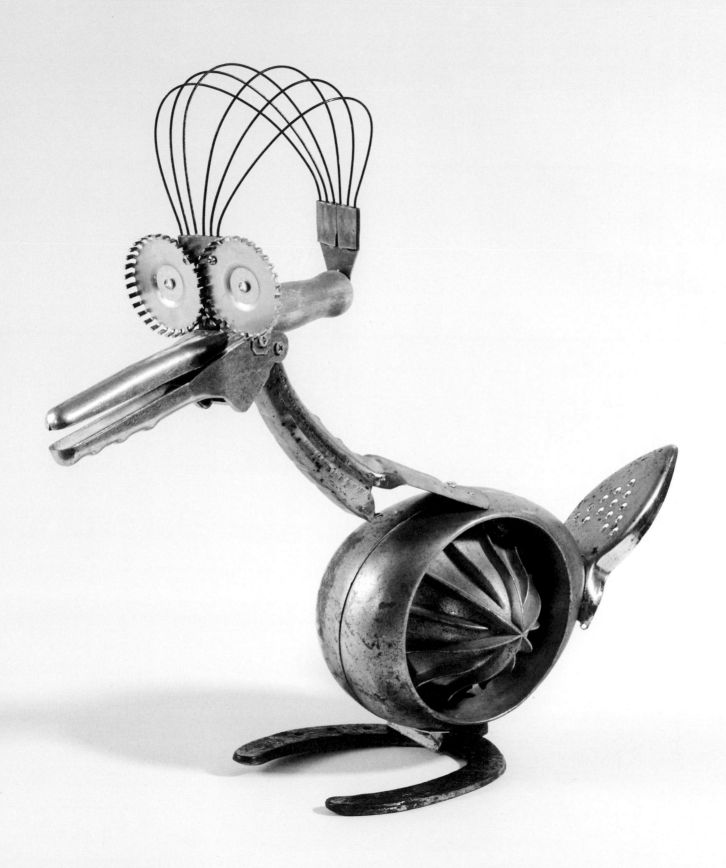

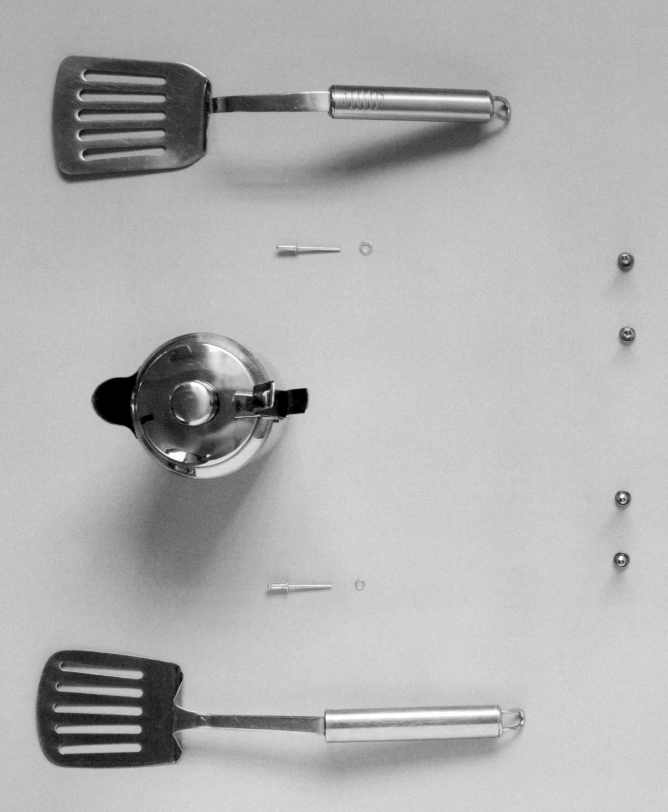

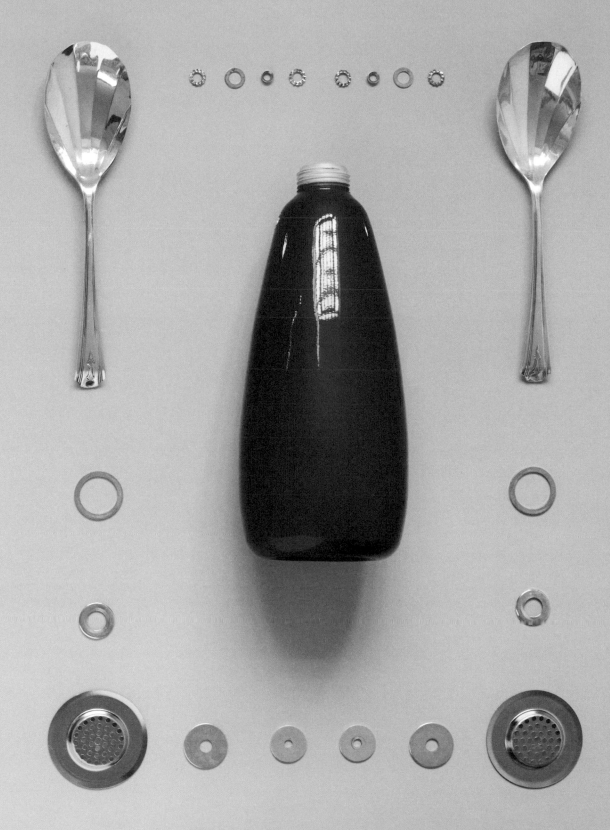

# HUG-A-BOT

## SCOTT GEOFFREY BLOOD

**SIZE**
60 x 40 cm
(23½ x 15¾ in)

**WEIGHT**
1.2 kg (2 lb 10 oz)

**COMPONENTS**
1 stainless steel teapot

1 soda siphon (top removed)

2 fluted serving spoons

2 silver-plated spatulas (turners)

2 sink strainer plugs

4 self-tapping screws

2 rivets

Assorted washers and locking washers

**TOOLS**
Drill

Angle grinder

Vice

Hammer

Pliers

Rivet gun

Epoxy glue

Screwdriver

Hand file

*I find most of the parts for my pieces at car boot (yard) sales and flea markets where I look at things in terms of shape and material as much as function. One day, I saw a stainless steel teapot that looked like a head three-quarters complete – all it needed was some eyes. I paired it with a brightly coloured soda siphon, which makes an ideal body, and some ever-reliable spoons and spatulas (turners), which become fantastic and expressive limbs. This really is all that's needed to make Hug-A-Bot, a happy, huggable robot who conforms beautifully to my "less is more" sculpture philosophy.*

## [ METHOD ]

To start, drill two small holes in the inverted teapot to position the eyes. Then, use an angle grinder to cut through the bottom one of the two joins of the teapot handle, file down any sharp edges and, taking a pair of pliers, twist this handle 180 degrees to form the neck of your bot.

To make the eyes, glue together two sets of washers of your choice, then glue them into the recesses of the two sink strainer plugs and fix them to the head by riveting them through the small holes.

Next, take the old soda siphon and drill four holes into it – one for each limb – letting any old soda drain out. Take your spoons and spatulas (turners) and bend them into the desired shapes using a vice. Drill small holes into the handles and fix them to the back and bottom of the body with self-tapping screws and a combination of washers and locking washers to stop them from working loose.

To complete your happy, huggable robot, add the head by simply sliding the teapot handle neck into the soda siphon body, opening the teapot lid a little to create the characterful mouth. Once you have found all of your pieces, it takes just 2–3 hours to assemble this simple but very effective little robot.

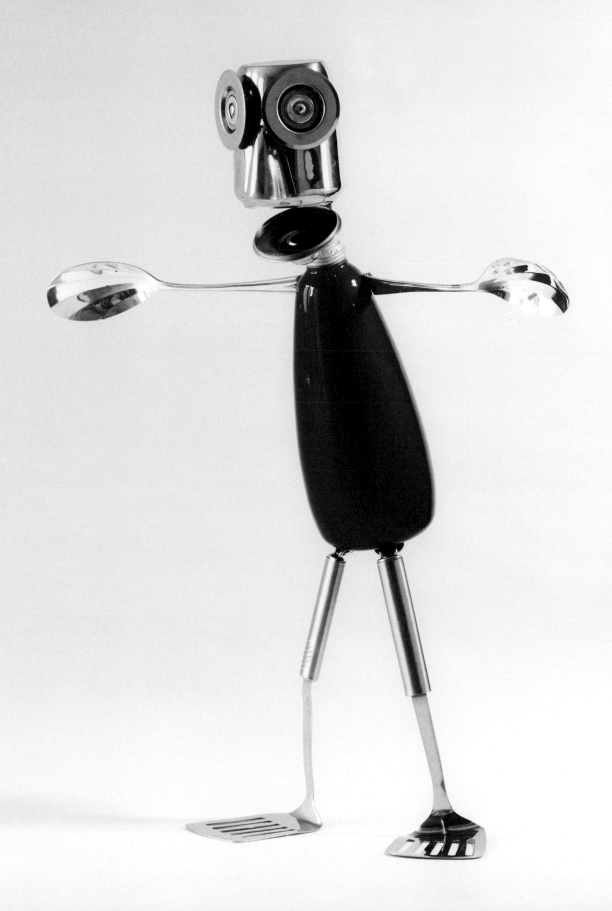

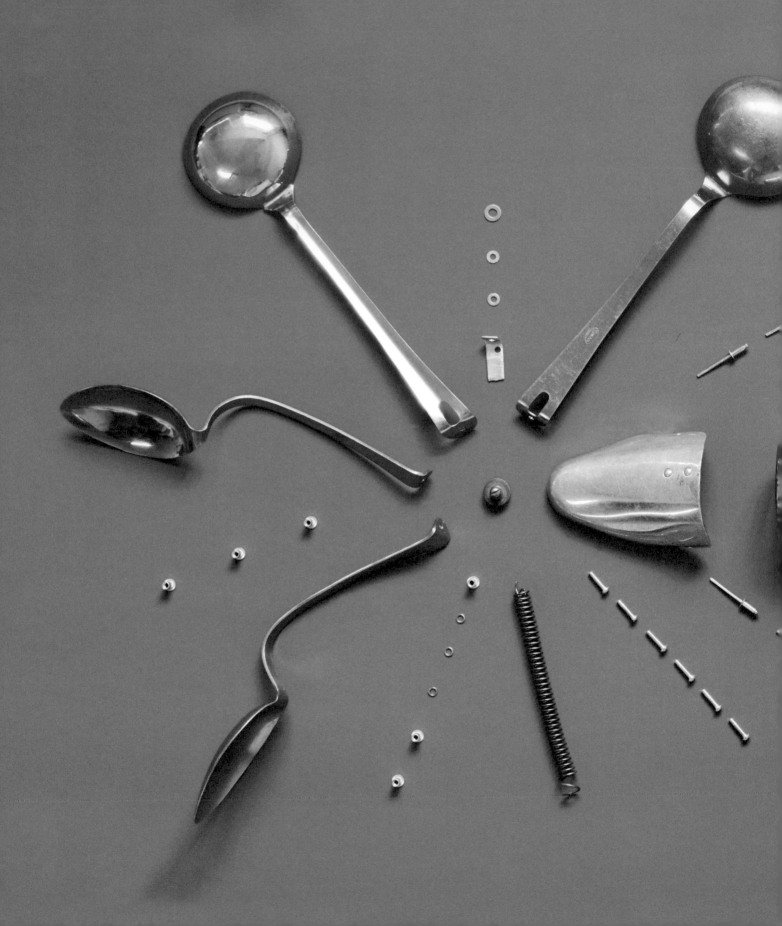

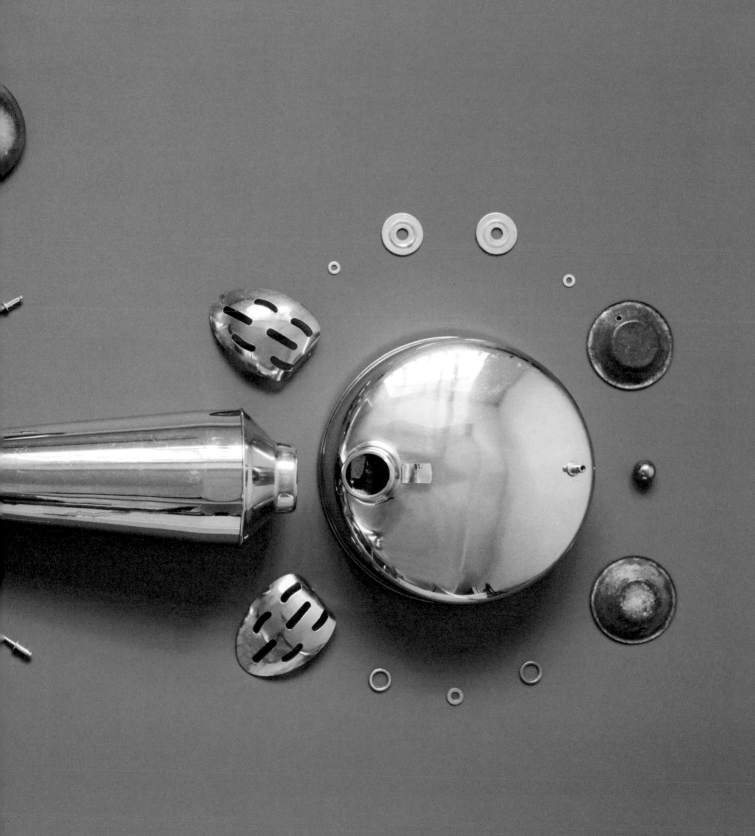

# STASH-A-BOT DOG

## SCOTT GEOFFREY BLOOD

**SIZE**
40 x 30 cm
(15¾ x 12 in)

**WEIGHT**
1.1 kg (2 lb 7 oz)

**COMPONENTS**
1 cocktail shaker

1 stainless steel kettle
(minus handle)

1 shoe stretcher

1 brass knob

1 large spring

1 ball bearing

2 small tart tins

2 slotted spoons (minus
handles)

4 serving spoons

1 small chrome bracket

6 small rivets

4 rivet nuts

Assorted bolts and
washers

**TOOLS**
Drill

Hacksaw

Hand file

Vice

Plastic mallet

Pliers

Rivet gun

Epoxy glue

*I love dogs, so I was always on the lookout for a simple way to make one. I'd made robots with kettle bodies before and thought this idea could be adapted for a dog, but what about the head? I had a half-finished ray gun with a cocktail shaker for its body and thought that it might work as a dog's head, and it did. The tricky part was making it not look like a pig's head with its flat, round end. A doorknob nose helped with that. Because the head is a cocktail shaker, the back of it can be removed and things can be stored in the head – a secret little stash. Hence the name Stash-A-Bot Dog.*

### [ METHOD ]

As with most bots, it's the head that provides the character, so that's where to begin. Take two small tart tins for the eyes, slotted spoon bowls for the ears, and a shoe stretcher to provide his happy grin. Position two sets of washers in the tart tins for eyes, bend the spoon bowls as necessary, and drill and rivet each piece into place on the cocktail-shaker head. Add the small brass knob for a nose and your dog starts to come alive.

Bend the handles of the four serving spoons – with the help of a plastic mallet if required – to make the legs and paws, and fix these to the base of the steel kettle using rivet nuts and bolts. Unlike ordinary rivets, rivet nuts enable you to take the legs off and reposition them repeatedly until they are just right and your bot stands steadily.

To make the tail, slide one end of the spring onto the protrusion at the top of the kettle where the handle was attached, and push a ball bearing into the other end to give it some weight and a good waggle. Fix both with a little epoxy glue.

Finally, join the head to the body by taking the L-shaped bracket, drilling holes at each end of it as necessary and riveting one end to the kettle spout and the other to the back of the cocktail-shaker head. Altogether, assemblage is pretty straightforward and takes around 5 hours.

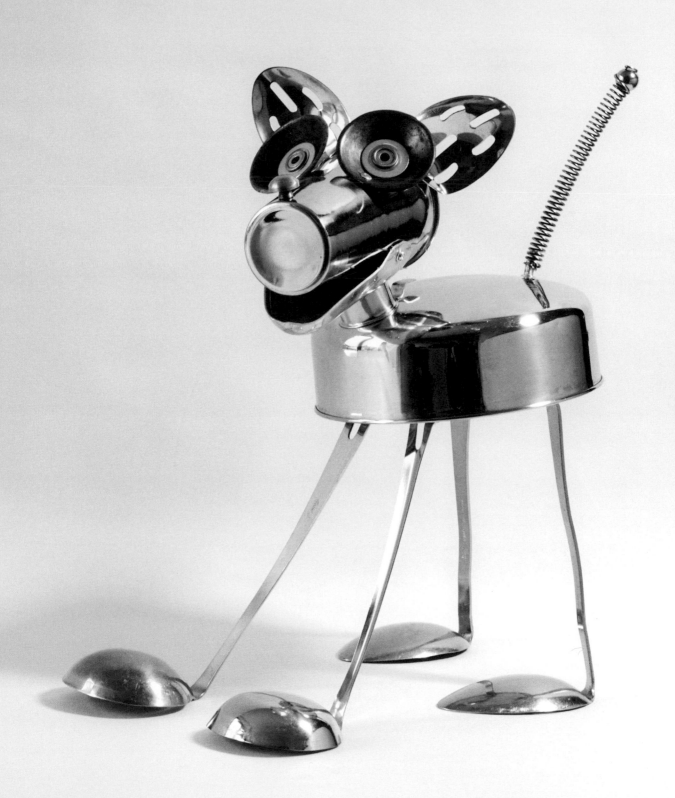

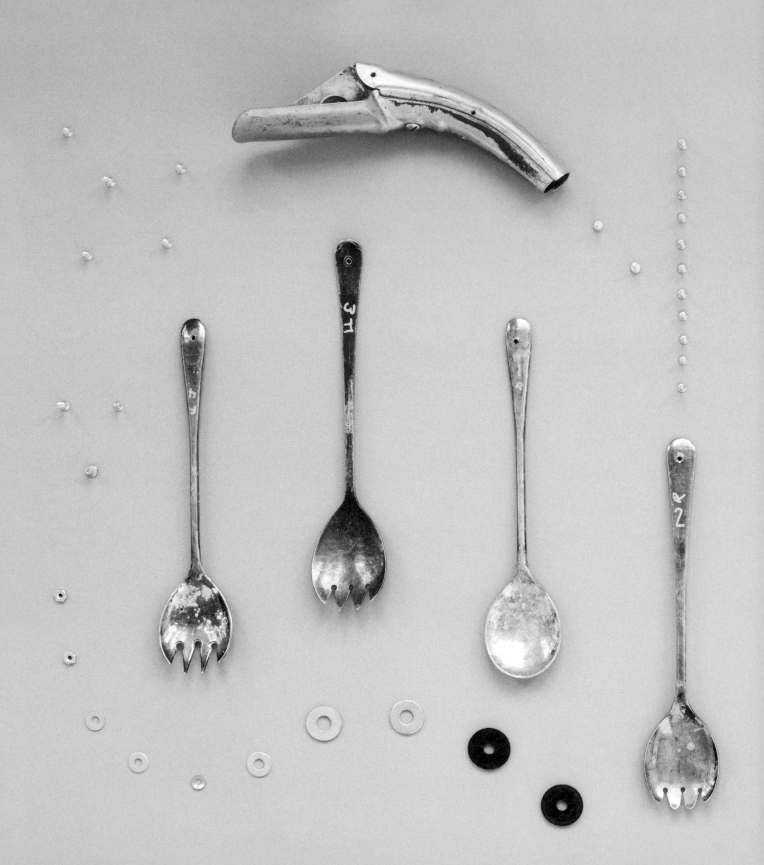

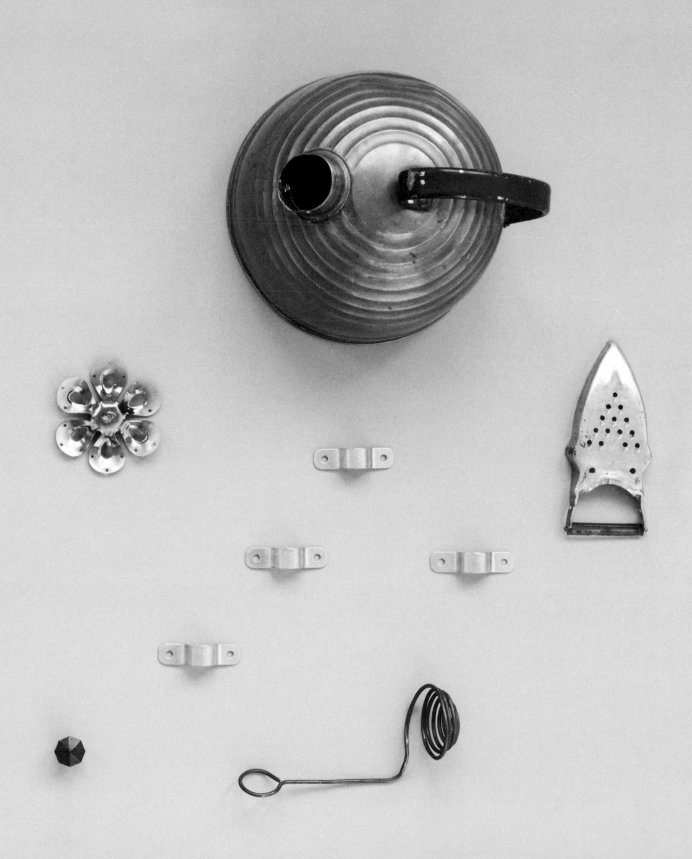

# TEA TURTLER

## DAVID MEAD

**SIZE**
25 x 23 cm
(10 x 9 in)

**WEIGHT**
1 kg (2 lb 3 oz)

**COMPONENTS**
1 copper teapot
1 oil-can spout
3 salad-server forks
1 salad-server spoon
1 potato peeler
1 wire egg holder
4 copper brackets
6 metal washers
2 rubber washers
2 metal nuts
21 metal screws
1 toy pot lid
1 decorative metal flower

**TOOLS**
Drill
Magnetic screwdriver
Pliers

*My wife found a broken copper teapot for pennies at a second-hand (thrift) store and, when I saw it, its shape immediately reminded me of a turtle from a children's book I'd loved as a child. As his face came together, I started imagining the somewhat snooty voice that might spout from this creature's metal throat. I was convinced that he'd look down on anyone who chose a beverage other than a freshly brewed cup of breakfast tea, and he'd certainly keep track of what each person was drinking. The teetotal* Tea Turtler *was born. And I get the feeling he dislikes me... because I don't drink tea!*

### [ METHOD ]

Once you have sourced your pieces and have an idea of your assembled creature in your mind, you can begin. Be gentle when working with copper – it is so much softer than other metals, and screws can tear or damage it quite easily. *Tea Turtler* will take a couple of days to complete.

To start, take an oil-can spout, which makes for a nice curved turtle neck, and simply place the spout end into the teapot spout to create a perfect turtle head, with tongue and all. Fix in place with a screw on either side of the teapot spout.

Next, work on the beak and top portion of the head by piecing together the potato peeler, egg holder, metal flower decoration and tiny toy pot lid. Screw into place as appropriate. Create the eyes by stacking different-sized washers until you are happy with their appearance, and screw them into the base of the beak. With each piece that you add, you'll find the personality of your character developing, be it joyful, eager-to-please or snooty, as *Tea Turtler* appears to me.

For the legs, take the four salad servers and criss-cross them underneath the base of the teapot. Use the copper brackets and screws to fix them in place. This took me several attempts because the copper base was very soft but, fortunately, any mistakes can be hidden underneath his belly!

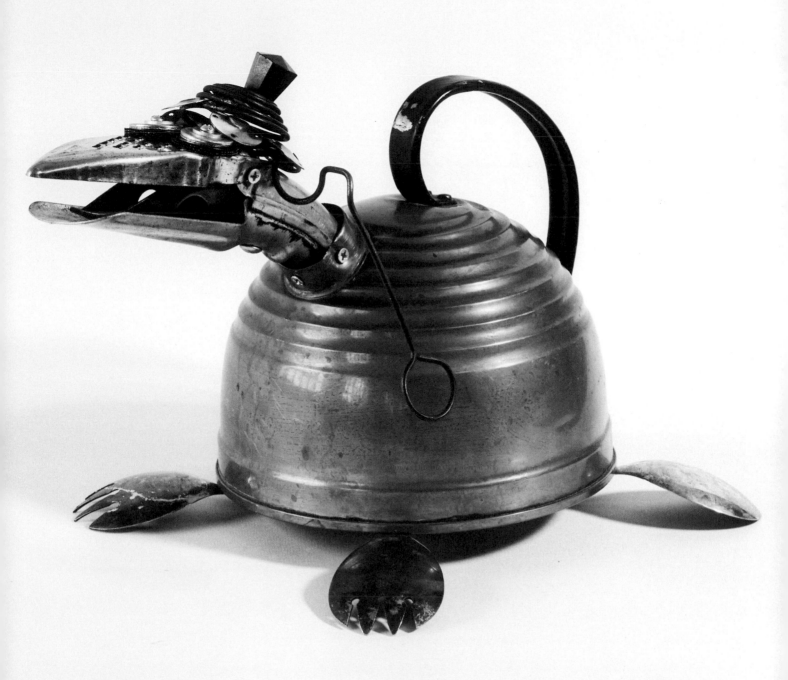

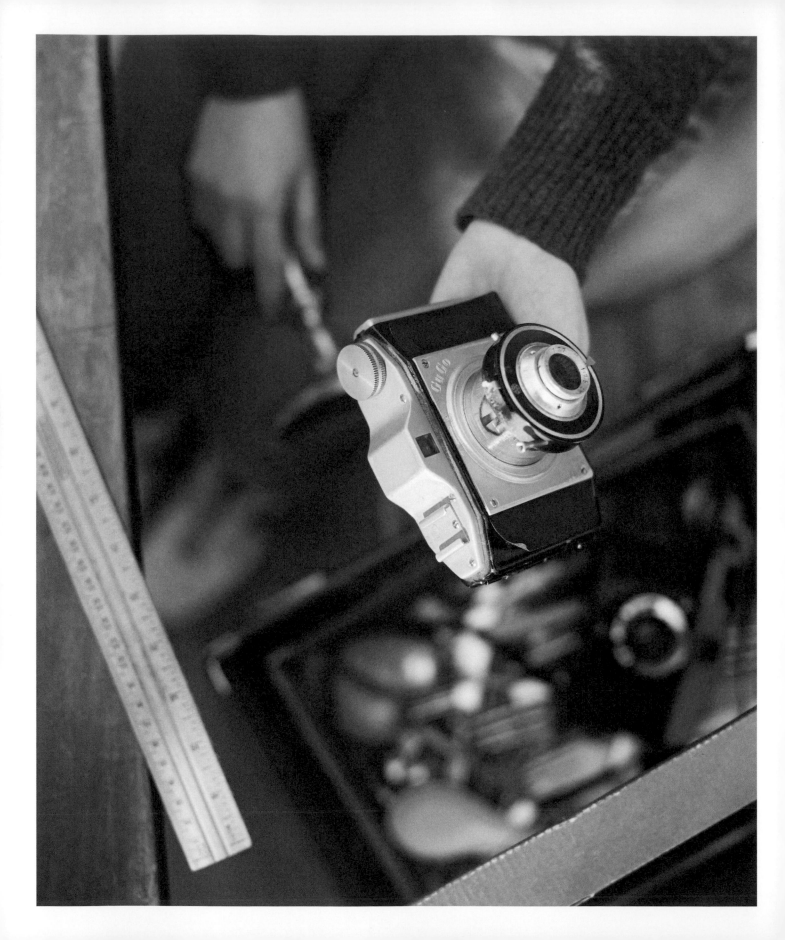

# HOBBIES AND LEISURE

Transform a post-war camera into a robot head with a searching aperture-eye and you will immediately lend a futuristic, cyclops-like quality to your project. Old cameras are a flea-market classic – they are pretty easy to come by and usually have a little tripod mount underneath them, which means they are ready to be screwed onto anything.

Unused sports equipment such as a wooden tennis racket or a golf club can also provide some useful robot elements; a broken bicycle is a treasure trove of reusable bot parts – take it apart, lay out all the bits and pieces in front of you, and see what emerges...

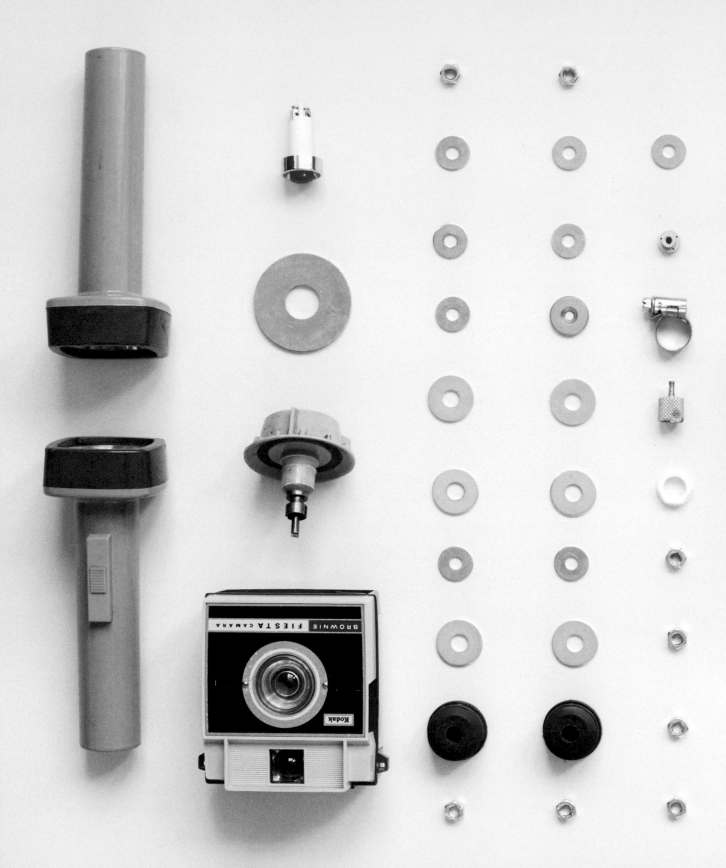

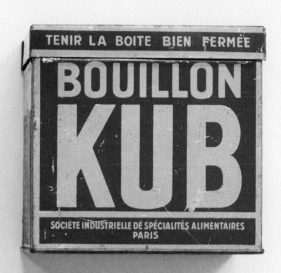

# KUB KODAK

## JAVIER ARCOS PITARQUE

**SIZE**
40 cm x 16 cm
(15¾ x 6¼ in)

**WEIGHT**
1.2 kg (2 lb 10 oz)

**COMPONENTS**
1 Kodak Fiesta camera
  c.1964

1 empty tin of "Kub" stock
  (bouillon) cubes

2 stabilizer rods from a
  child's bicycle

2 late 1960s torches
  (flashlights)

1 tuner dial from 1960s
  television set

1 small red bulb

1 small white bulb and
  its fixings

5 bolts

8 nuts

16 washers

2 black rubber spacers

1 white plastic spacer

16 small metal rings

6 medium metal rings

**TOOLS**
Screwdriver
Hammer
Drill

*Like all of my creations, KUB Kodak was born from my need to take time out from a busy job as creative director of an advertising agency in Madrid, Spain. Sourcing and building this little guy gave me precious moments of relaxation, and also helped me sort out my creative ideas. I found the parts for him in different flea markets across Europe – the body came from Paris, the legs from Lisbon, and the rest of the pieces from Madrid. He is simply named after the brands featured on his body and head – KUB Kodak – and I like to think of him as a kind robot who knows how to listen to his owner.*

### [ METHOD ]

First, find the parts you need to create your robot. Gather together a lot of pieces and try out different combinations. When building my pieces, I start by putting together the found objects that, for me, have a certain beauty. This almost always results in a humanoid-shaped robot figure. As with *KUB Kodak*, the central body is usually made from the box of an old product – a tin of soup stock cubes in this case – and I always like to be able to see the packaging design in the finished bot.

Once you have identified the main body of the piece, go looking for the head, arms and legs and, finally, the items that will embellish your bot. For me, these are usually buttons, dials and bulbs from old music devices, radios, cameras, etc. *KUB Kodak* took me eight months to finish because I couldn't find the ideal pieces for his legs. Eventually, I found two 1960s beige torches (flashlights) in a market in Lisbon, *et voila*! *KUB* was ready to be assembled. I simply pierced the relevant objects and fixed the pieces together with nuts and bolts, and the help of a handful of washers and spacers to strengthen the bond and add stability. I added rings to his legs and arms to enhance his robot look.

To create a similar robot, start by collecting everyday household objects that you might otherwise throw away. Play with combinations of different items and start with something easy, perhaps simply sticking pieces together with glue. As you gain in confidence, you can experiment with a wider variety of materials and bonding techniques.

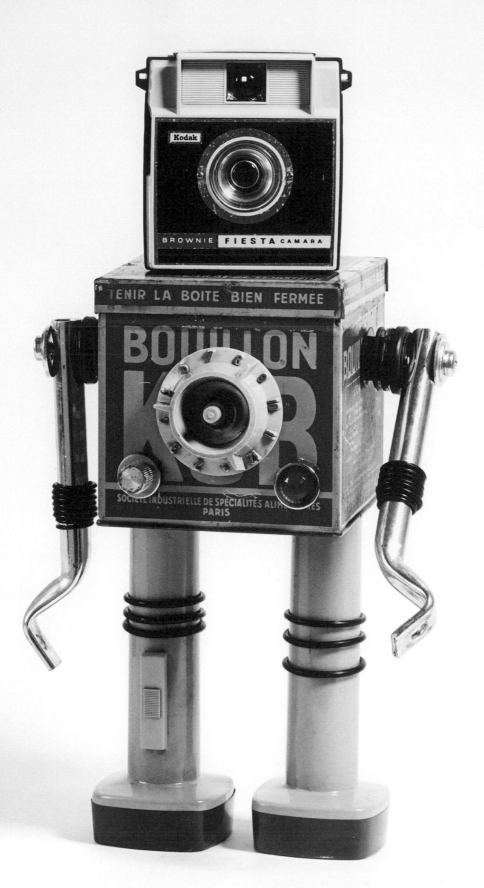

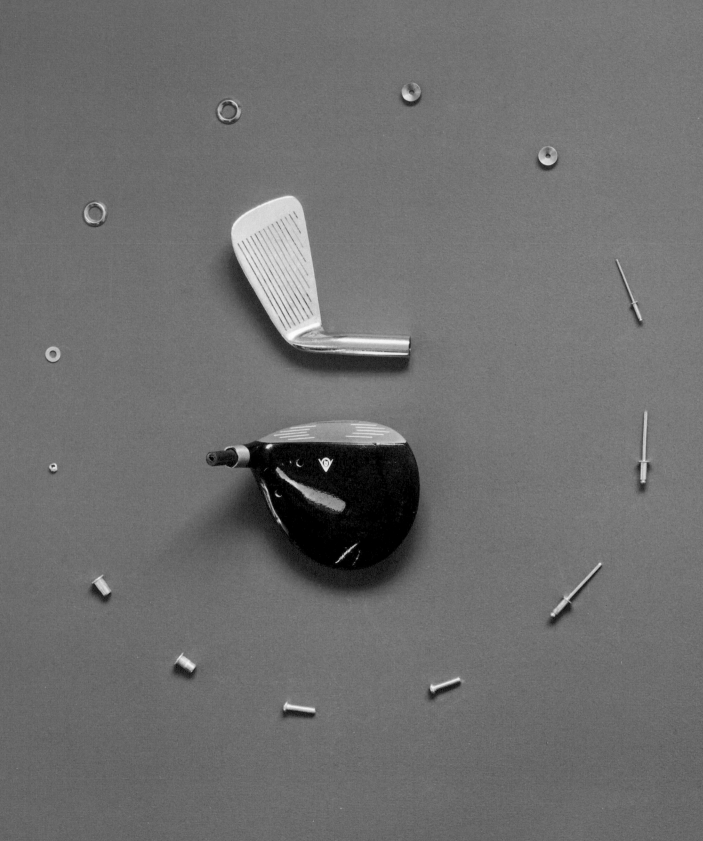

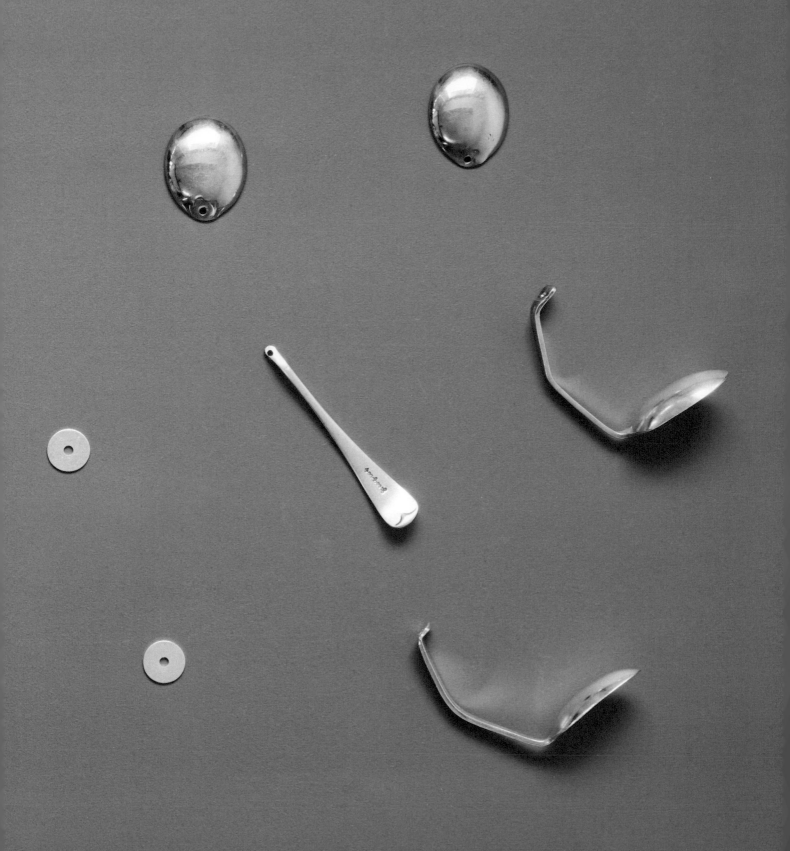

# GOOFY GOLF BIRD

## SCOTT GEOFFREY BLOOD

**SIZE**
22 x 14 cm
(8½ x 5½ in)

**WEIGHT**
0.7 kg (1 lb 8 oz)

**COMPONENTS**
1 golf club driver head
(shown with small
threaded bar)
1 golf club iron head
4 silver-plated spoons
2 small copper discs
Selection of rivets and
washers

**TOOLS**
Drill
Bench grinder
Hacksaw
Hand file
Vice
Plastic mallet
Pliers
Rivet gun
Epoxy glue

*I think the name Goofy Golf Bird is pretty self-explanatory. It came about when I decided that I wanted to express my creativity in an eco-friendly way. I saw a lot of unwanted golf clubs at car boot (yard) sales and flea markets and inspiration struck when I put an iron and a driver together and it looked, to me, like a duck on a lake. Then it was a case of figuring out the minimum that needed to be added to the piece and how to fix it all together. I've since made many such creatures, tweaking the design here and there – I just love doing it.*

### [ METHOD ]

First, clean and polish all of your pieces until gleaming. Then cut the handles off two of the spoons – the spoon bowls will be the wings – retaining one handle to become the tail of your bird. Also cut the shafts off the golf clubs, leaving the desired neck length, and file down all holes and cuts with a bench grinder and/or hand file.

Next, drill five small holes into the driver and one into each spoon, or part of spoon, at the point where it will be fixed to the body of the bird. Then, bend the spoon wings, legs and tail into your desired shapes using a plastic mallet and a vice, and fix them to the golf club driver body with rivets. This can all be fine-tuned with pliers, especially the legs, so the bird is balanced and stands firm.

Now, for the head. Make two eyes from a selection of washers and discs of varying sizes and colours, glue them together and then glue the eyes to the iron with strong epoxy. Drill a hole into the shaft of the driver club, which is the bird's neck, and glue in a short length of threaded bar. You can then simply slide on the head of the golf club iron. This will enable you to pose the head at different angles, but it can fall off if the bird is turned upside down, so you may wish to glue it in place.

Altogether, once your pieces are ready, it should take little more than 3.5 hours to assemble your very own *Goofy Golf Bird*.

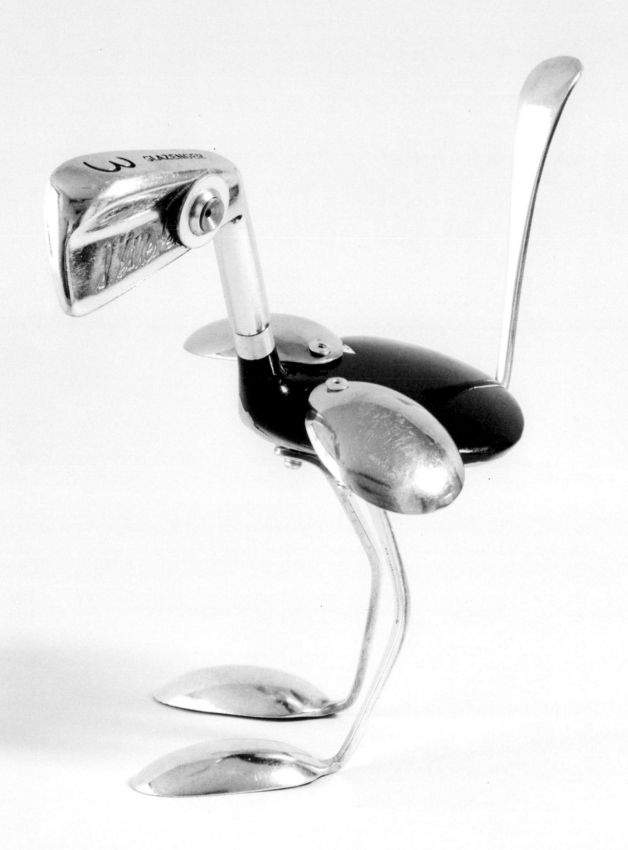

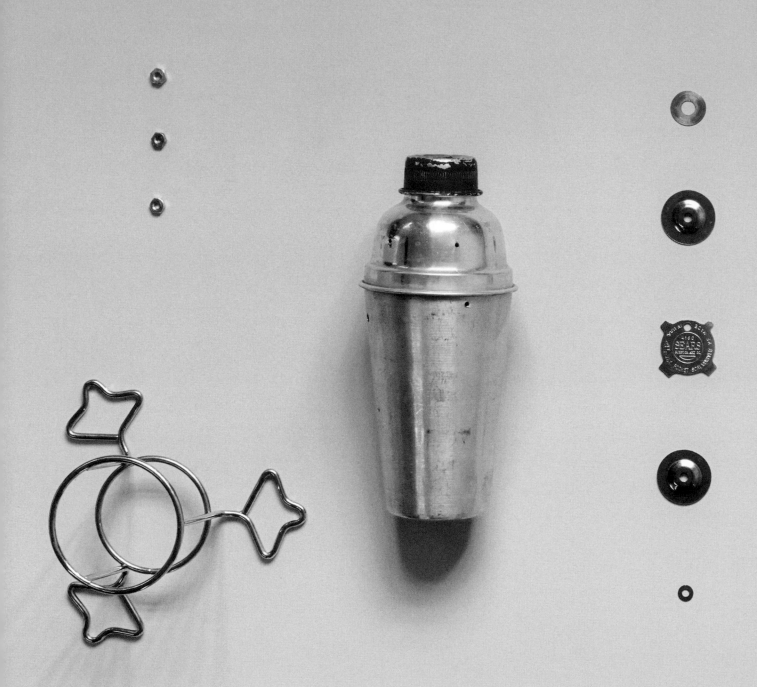

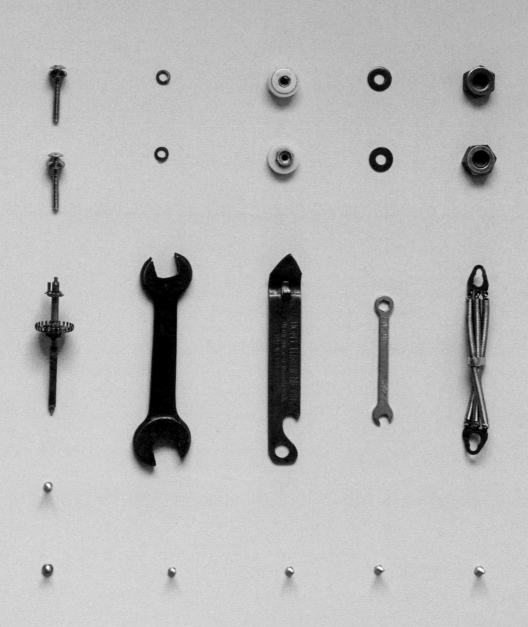

# UNIVERSAL TOOL GUY

## AMY KNUTSON

**SIZE**
30 x 15 cm
   (12 x 6 in)

**WEIGHT**
0.5 kg (1 lb 2 oz)

**COMPONENTS**
1 vintage cocktail shaker

1 red clock gear

1 "4-in-1" screwdriver
   badge

1 box end wrench

1 can opener

1 small wrench from
   child's toy toolkit

1 stretchy strap

1 red bottle top

1 3-legged base
   (provenance unknown)

6 screws

2 bolts

2 nuts

Assorted washers

**TOOLS**
Epoxy glue

Wrench

Screwdriver

Drill press

*I made this little guy when I realized that I hadn't actually made a traditional "robot" before. My pieces were more android-human or animal forms. Universal Tool Guy is all bot. The tool guy theme just evolved as I pulled pieces together to use for him. His name was easy to pick at that point. To me, he is the friendly carpenter who will do whatever you ask with a smile, and loves his work. But when the whistle blows, he's popping a beer with his buddies and kicking back. He came together pretty quickly for me, and he's one of my favourites because of his big, happy smile.*

## [ METHOD ]

Gather all of your found parts together – for *Tool Guy* I sourced these from garage sales, second-hand (thrift) shops and my own workshop – and start with the cocktail shaker, which forms his body and head. Drill a small hole in an old red bottle top, use a drop of epoxy to fix the clock gear on top to make his hat and, in turn, glue this to the lid of the cocktail shaker. Attach his eyes, each made by stacking and gluing three washers of different sizes together, by screwing them to the front of the shaker lid.

For *Tool Guy*'s mismatched arms, drill a hole in each side of the cocktail shaker and take the box end wrench and can opener – both of which already have a hole to use for assembly – and fix one to each side with a nut and a bolt. Screw the badge into his chest to wear as a medallion and wind the stretchy strap around his body for his tool belt.

Finally, set him in his "legs" with some epoxy glue and slip the child's tool kit wrench into his belt for easy reaching. Assembly should take no more than an hour and a half once all of the pieces have been chosen and collected.

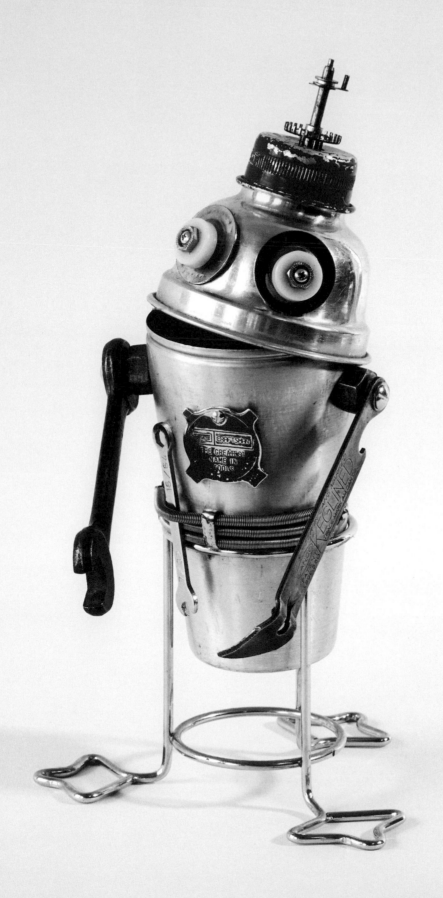

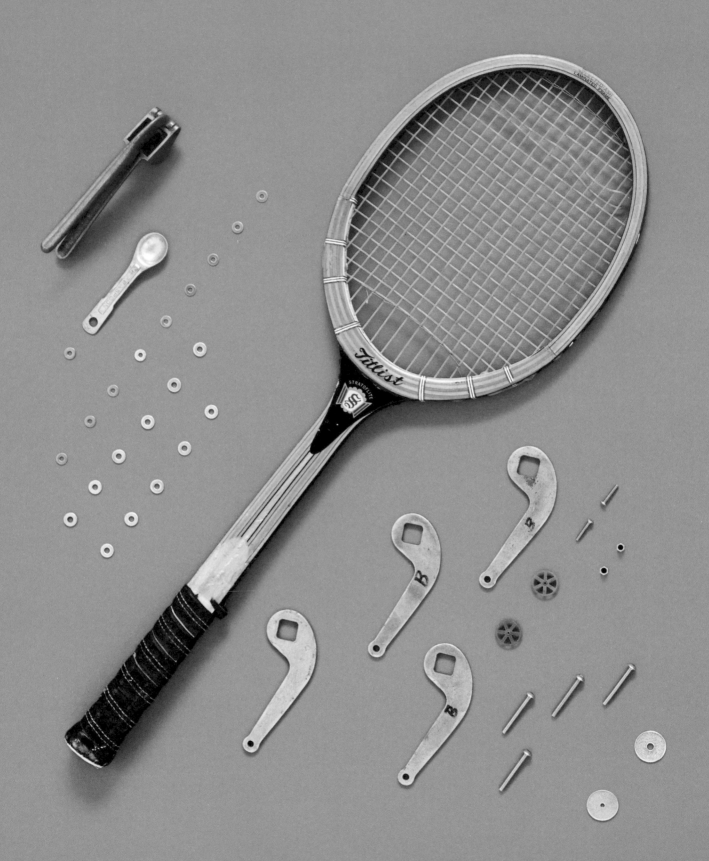

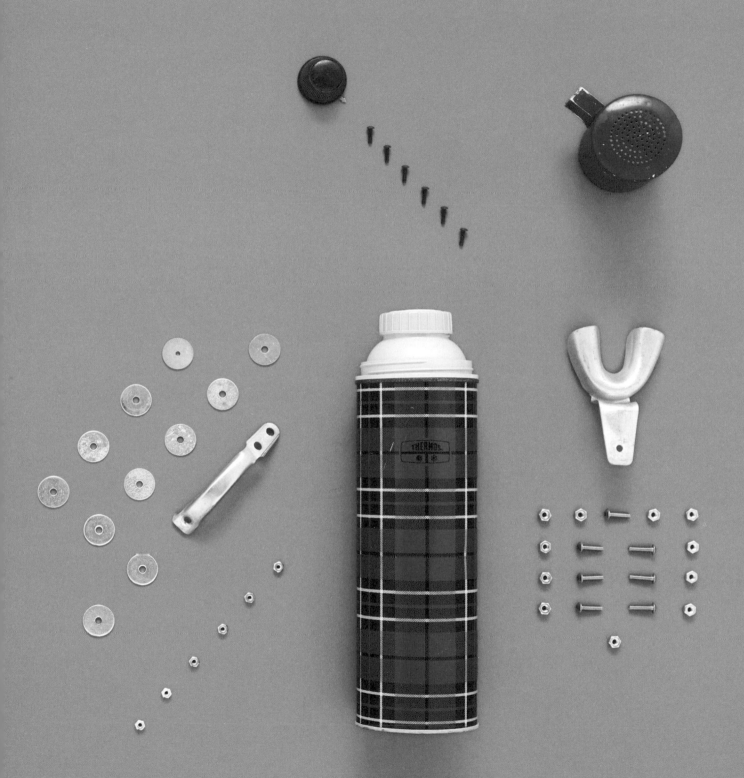

# ROCKING ROVER

## PAUL LOUGHRIDGE

**SIZE**
46 x 26.5 cm
(18 x 10½ in)

**WEIGHT**
1.1 kg (2 lb 7 oz)

**COMPONENTS**
1 1973 steel thermos

4 bicycle coaster brake arms

1 aluminium (aluminum) salt shaker, large

1 bicycle reflector bracket

2 pocket watch gears

1 auto repair meter knob

1 garlic press

1 kitchen measuring spoon

1 dental impression tray

1 retired wooden tennis racket

34 assorted washers

19 assorted bolts and screws

19 assorted small nuts

**TOOLS**
Hacksaw
Hand files
Plane
Tin snips
Drill
Ratchet wrench
Socket wrench

*Rocking Rover is my little K-9 buddy who was conceived and designed over the course of a few evenings. I already had the 1973 plaid steel thermos, then decided to make a rocking puppy (as opposed to rocking horse), and raided my collection of unwanted kitchen and leisure items to find the right pieces. His aluminium (aluminum) salt-shaker head is a little heavier than his garlic-press tail, so he had to be internally weighted to achieve the correct stance. Who said you can't teach a 1973 thermos dog new tricks?*

## [ METHOD ]

Start by laying out all of your found pieces in line with your doggy design and cut them to the appropriate shapes as necessary, filing and planing any sharp edges. For *Rocking Rover*, I trimmed his two rocker treads from an old tennis racket, snipped the handle off an old red salt shaker for his head, sawed a dental impression tray in half for his flappy ears, trimmed a measuring spoon for his tongue, and dismantled a vintage steel thermos to use the shell for his body.

First, securely mount four matching bicycle coaster brake arms to the thermos to make his legs by drilling two holes each side of the thermos and fixing the brake arms with washers, nuts and bolts of suitable sizes. Because the thermos shell is hollow, you are able to hide most of the nuts and washers on the inside, making for a cleaner and less cluttered final piece.

Next, fix the tennis racket rockers to the bottom of the legs with some further drilling and bolting together. To complete the body, take the bowl half of the garlic press and bolt to the bottom end of the thermos to make Rover's perky tail.

For the puppy's head, attach the two pocket watch gears for eyes, the two halves of the dental impression tray for characterful flappy ears, the spoon for his tongue and the auto repair meter knob for his shiny black nose, drilling the necessary holes and screwing everything securely in place. Finally, use the bicycle reflector arm as a neck to join the head to the body, and *Rocking Rover* is fully housebroken and ready to go!

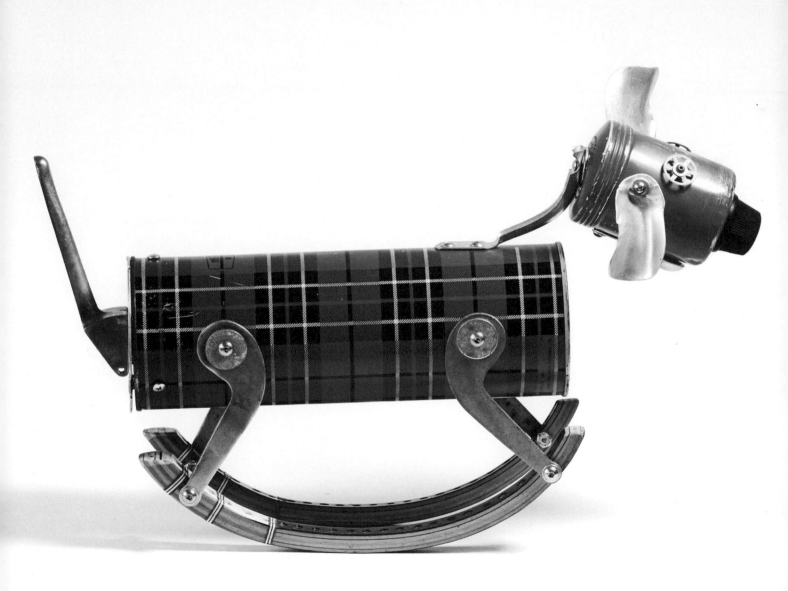

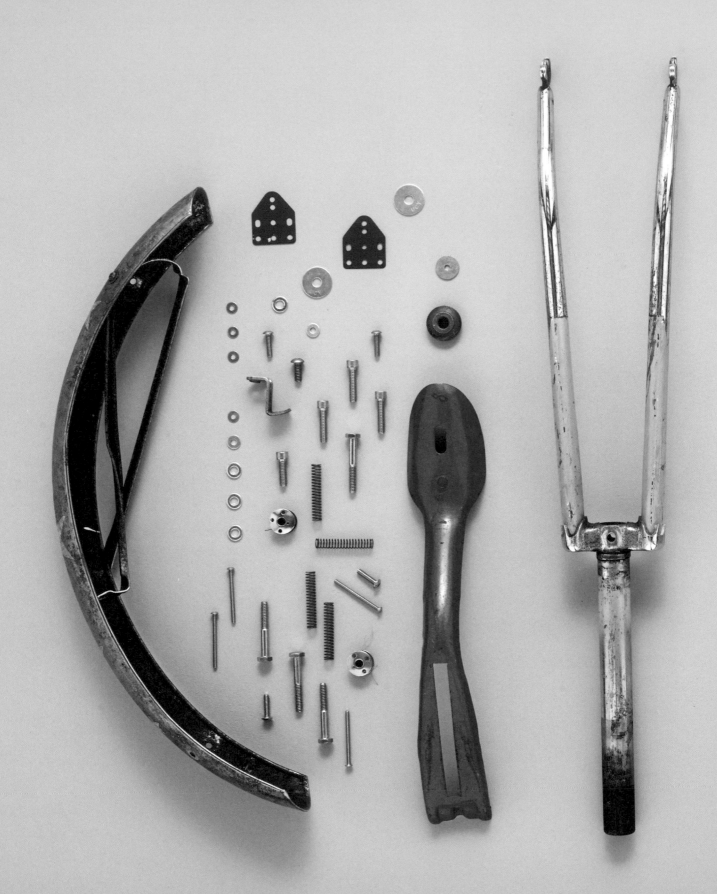

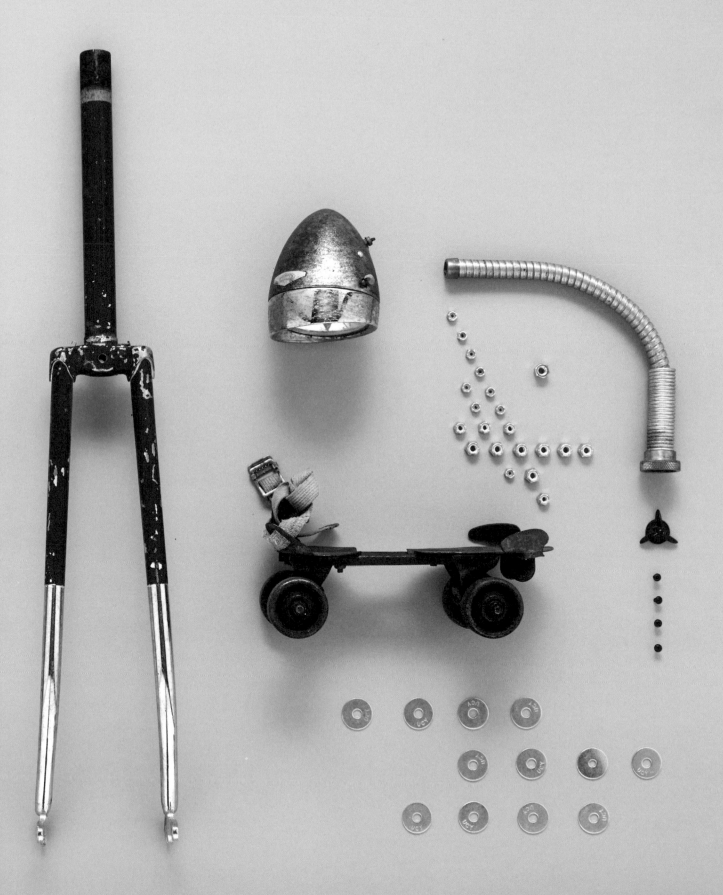

# RUSTY CAT

## PAUL LOUGHRIDGE

**SIZE**
46 x 56 cm
  (18 x 22 in)

**WEIGHT**
1.5 kg (3 lb 5 oz)

**COMPONENTS**
1 chrome tricycle fender

2 bicycle front fork sets

1 old bicycle headlight,
  rusty

1 adjustable shoe stretcher

4 springs

1 flexible petrol (gas) can
  spout

1 retired roller skate

1 old radio knob

2 Erector set corner
  brackets

2 vintage sewing bobbins

1 Z-bracket

Assorted washers, button-
  head screws, nuts and
  bolts

**TOOLS**
Hacksaw

Hand files

Tin snips

Drill

Allen keys

Ratchet wrench

Socket wrench

*My idea for creating* Rusty Cat *was to be as simple, delicate and cat-like as possible. I like to spend time dry-fitting my sculptures – holding bits and pieces together in search of that perfect combination and fit. To illustrate* Rusty's *feline grace, I selected an old tricycle fender for the arched body and bicycle forks as legs. I chose a rusty bicycle headlight for the head and a flexible petrol (gas) can spout for the rear. To ensure* Rusty's *mobility, I bolted a set of 1960s roller skate wheels to each leg – GO KITTY GO!*

## [ METHOD ]

To begin, take a hacksaw to cut apart both bicycle forks and trim these and the fender body to your desired length. Drill four holes in the fender and one in each fork, and use button-head screws to secure the legs to the body.

For the head, unscrew the back of the headlight so that you can drill fixing holes into it for the eyes, ears, whiskers and nose of your kitty. Attach the Erector set bracket ears, sewing bobbin eyes, old radio knob nose and four small spring whiskers with nuts and bolts. Then, screw the headlight back together and reverse-mount it onto the vintage shoe stretcher, which can be fashioned into a neck. Do this with as many nuts, bolts and washers as you need for your particular pieces, tightly fixing them in place with a socket wrench.

Secure the neck to the body in a similar fashion, using a Z-bracket to join the two together. Work out the best places to drill and bolt depending on the pieces you are using. The arched shape of the fender body hides the ends of some of these fixings beautifully. Next, bolt the petrol (gas) can spout to the end of the body to make *Rusty's* tail.

Finally, remove the wheels from the old roller skate and bolt on to the bottom of each bicycle fork leg, making use of the holes where the wheel was attached. Once you've found the parts for your cat, it should take no more than a day to build. I like to use a "cold assembly" technique of drilling and bolting all pieces together but you may be able to use glue for some of the fixings if you prefer.

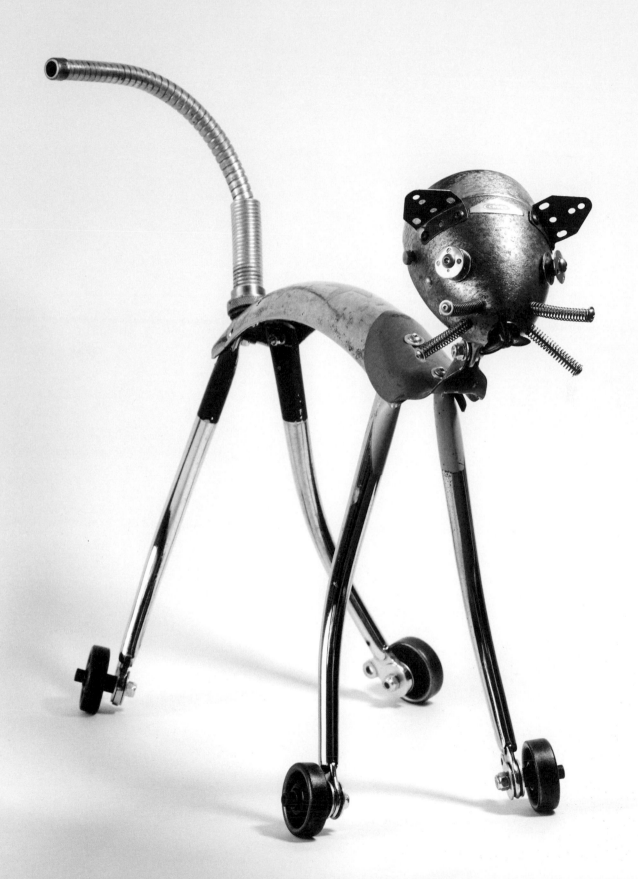

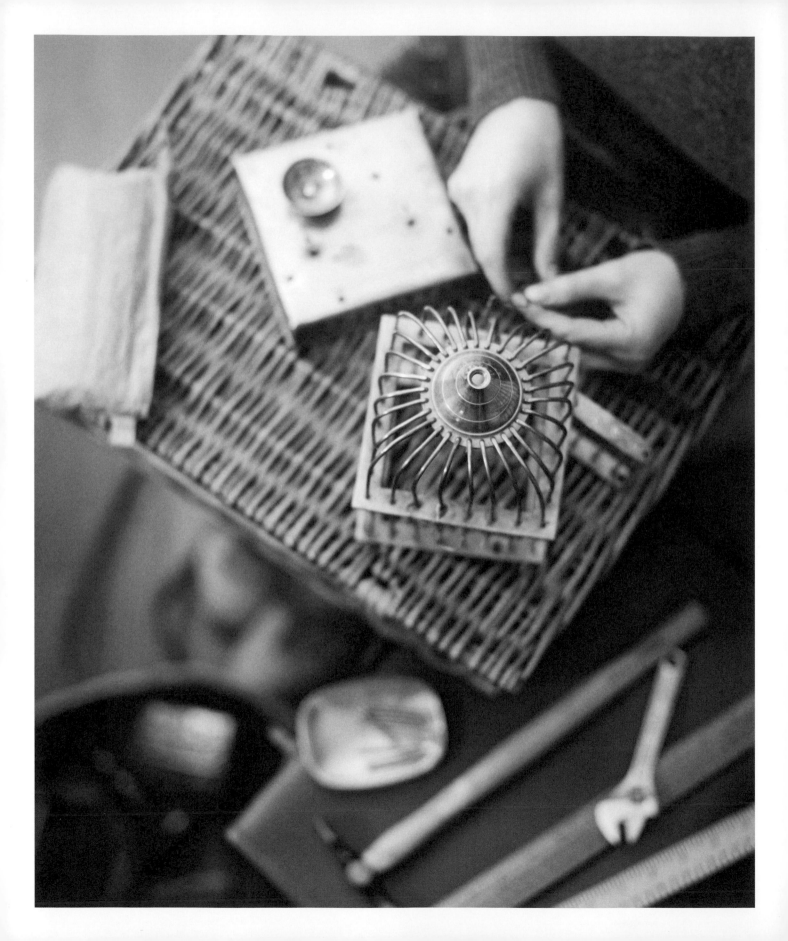

# FROM THE SCRAPYARD

Old mechanical parts, deformed tools, battery chargers, electric meters, clamps, springs, wires, locks – these are all excellent ingredients for creating a scrapyard robot. There is something incredibly satisfying and a little bit romantic about building a charming anthropomorphic bot out of things that have long since lost their functionality – to a point where you can hardly identify them – and have been pronounced by their owners to be useless junk.

Whether they are simple constructions or complex, multi-part robots, there is definitely an industrial, often steely aesthetic that underpins the visual language of these scrapyard-based projects.

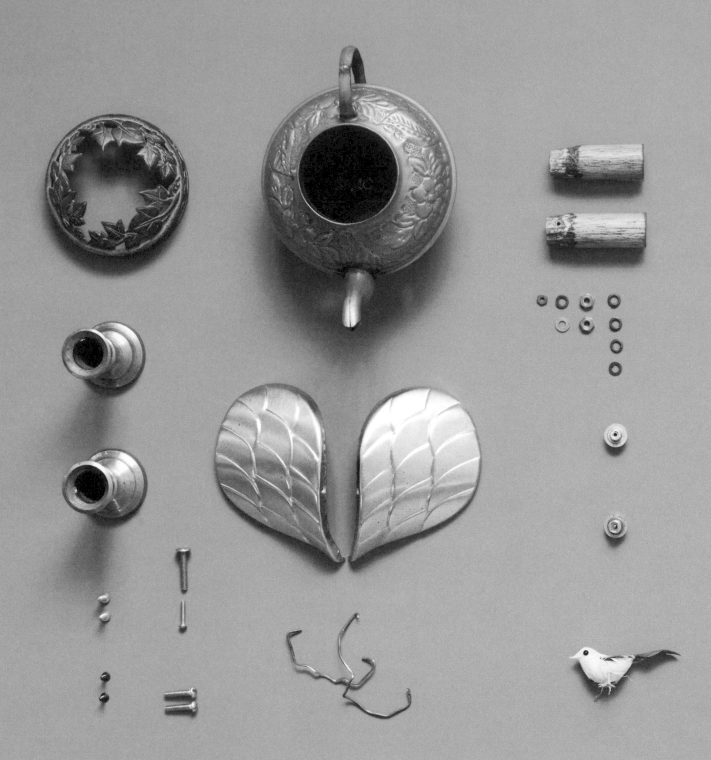

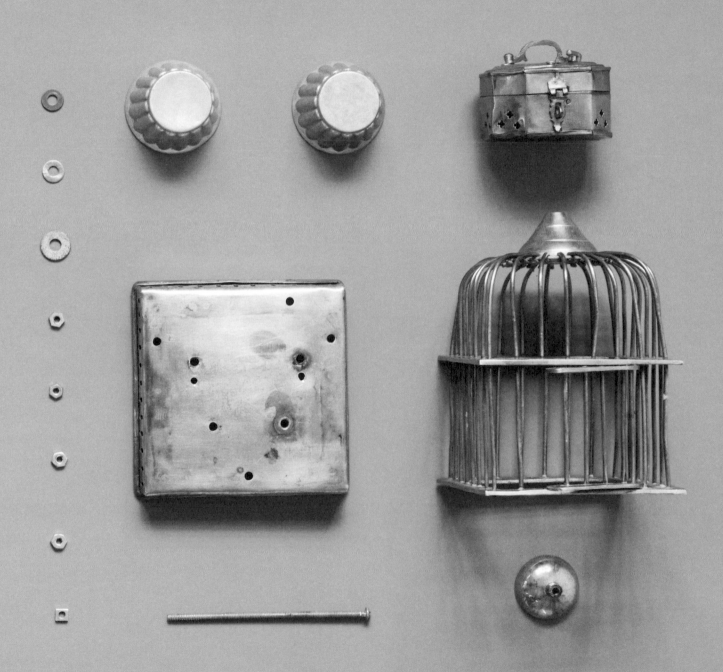

# AURORA THE FLIGHTLESS BIRD

## AMY KNUTSON

**SIZE**
43 x 16.5 cm
(17 x 6½ in)

**WEIGHT**
1.7 kg (3 lb 12 oz)

**COMPONENTS**
1 small brass teapot

1 small brass birdcage and
separate base

1 small bird

1 small brass cup

1 small brass box plus
music box to fit inside

1 brass ivy vine crown

2 wings from 1960s owl
transistor radio

2 eyes from same radio

2 wooden dowels

2 brass candlesticks

2 tart tins

1 long bolt

Assorted nuts, bolts,
screws and washers

Copper wire

**TOOLS**
Epoxy glue

Screwdriver

Drill

*The idea for this piece came to me over several months. I had the birdcage, and thought I would make a small bird to sit inside it, but that never really came together. Instead, it developed into the idea of the cage actually being part of the bird. I found the other pieces by rummaging through assorted garage sales and second-hand (thrift) shops. The name "Aurora" is a nice airborne-sounding name for a flightless bird. I imagine that the little bird on her shoulder (Simon) has escaped from the cage and that he and Aurora have become inseparable friends. Although flightless herself, through Simon, Aurora can see the whole world.*

### [ METHOD ]

To assemble *Aurora*, start with the birdcage and fix the wings to the side bars of the cage using copper wire. Next, take the teapot that will become the head and fix it, upside down, to the top of the cage with a vertical bolt so that it stands straight. Secure this bolt at the top of the head. Next, attach the ivy vine crown using epoxy glue. The eyes from the vintage owl transistor radio need to be set into holes drilled in the teapot and secured with epoxy.

For each leg, take a vintage tart tin and fix with epoxy to the bottom of a brass candlestick. Then attach wooden dowels to the candlesticks with a small brass set screw. Remove the base of the birdcage and mark on it the desired position of the dowels. Then drill small holes, insert a wood screw through the hole and screw into the end grain of the dowel. Before putting the birdcage back together, glue the small brass cup inside at the bottom to be a feeder for the little bird.

Place a small birdsong music box into a small brass box and fix using two screws. Fix the little bird onto the shoulder of your piece using either copper wire or glue. And there you have it! *Aurora* has been assembled in 3–4 hours, using just epoxy glue and a few bolts and screws.

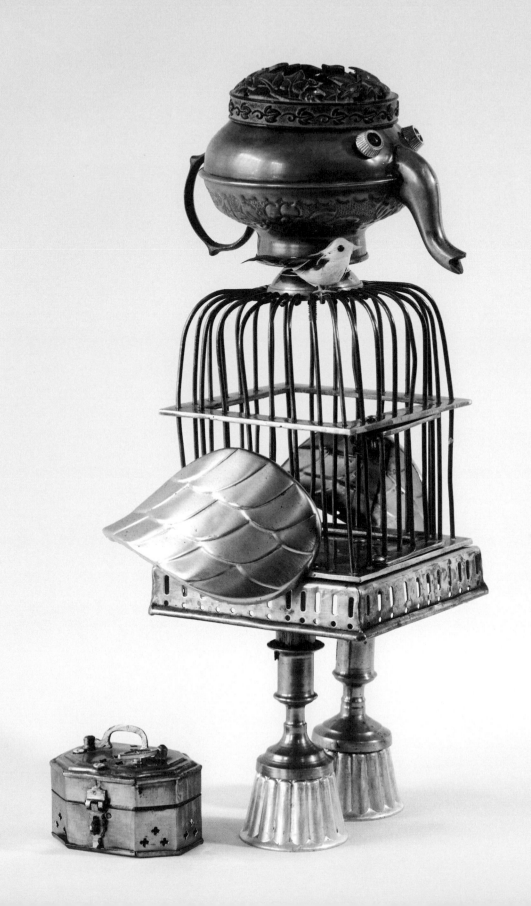

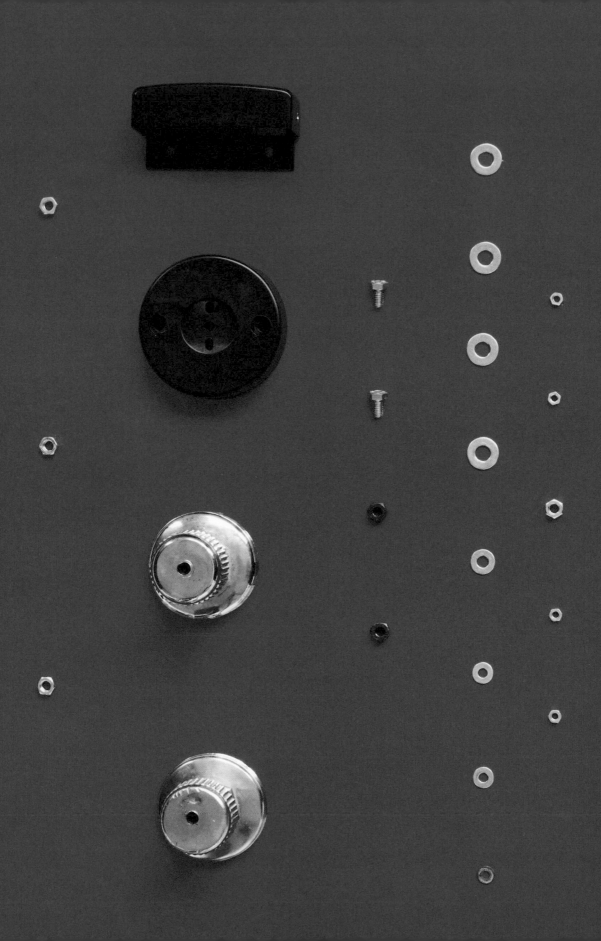

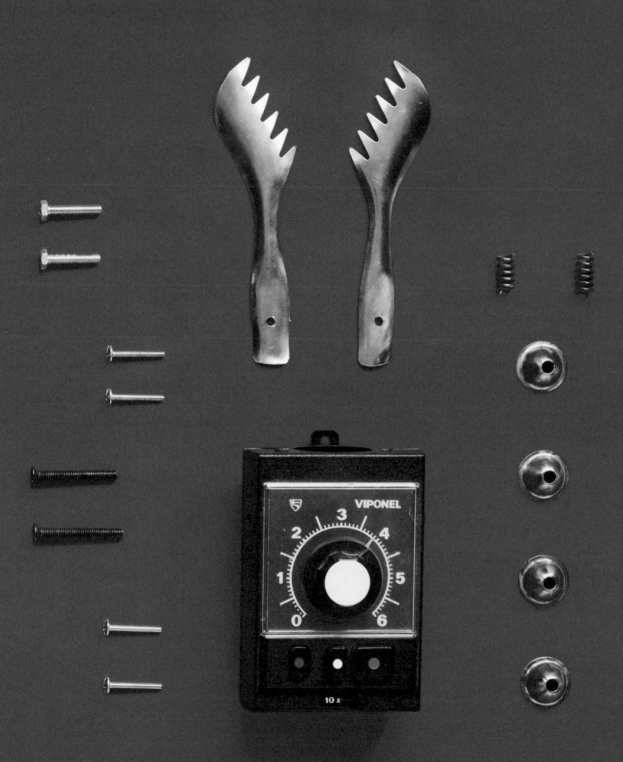

# BLACK

## GILLE MONTE RUICI

**SIZE**
30 x 13 cm
  (12 x 5 in)

**WEIGHT**
1.2 kg (2 lb 10 oz)

**COMPONENTS**
1 Viponel Labtime photo
  enlarger box

1 spaghetti spoon, halved

2 pieces of black plastic
  lock

2 boiler valves

2 springs

4 old plumbing spacer
  gauges

10 nuts

10 bolts

8 washers

**TOOLS**
Drill

Screwdriver

Wrench

*The making of a robot often begins with the discovery of a single piece that inspires me – in this case, it was a little black box with a dial and three buttons, which I found at a second-hand market. All of the other parts of Black were rescued and recycled from other unwanted items as well. Black's posture produces rather a severe and larger-than-life character, but one that is also sympathetic and watchful. With the dominant colour of the finished piece being black, and its straightforward and unassuming demeanour, I found it easy to name – Black!*

## [ METHOD ]

*Black* is a relatively small piece that requires more preparation time than actual assembly time. First, find all of the separate elements that you will need to construct the robot. Arms and legs are generally easy to find, but the body and head can be trickier.

Take two boiler valves, or similar, to act as legs, and cut a spaghetti spoon in half to make the arms. Using two of the plumbing spacer gauges for shoulders, bolt the arms to the sides of the body. The main body is a small timer case for an analogue photo enlarger, but any similar box with a dial will do the trick.

The head and neck are comprised of two pieces from a lock, the top part of which has been pierced to accommodate two eyes made from the other two spacer gauges (that were originally used to help install water pipes along a wall). To accentuate the head's robotic nature, I fixed a small spring to each side with a nut, a bolt and a washer to make two small horizontal antennae.

The assembly of the whole piece should be pretty uncomplicated – just pierce the pieces and fix them together. No technical knowledge or expensive tooling required! Once all of the parts have been prepared and laid out, assembly should take no more than half an hour.

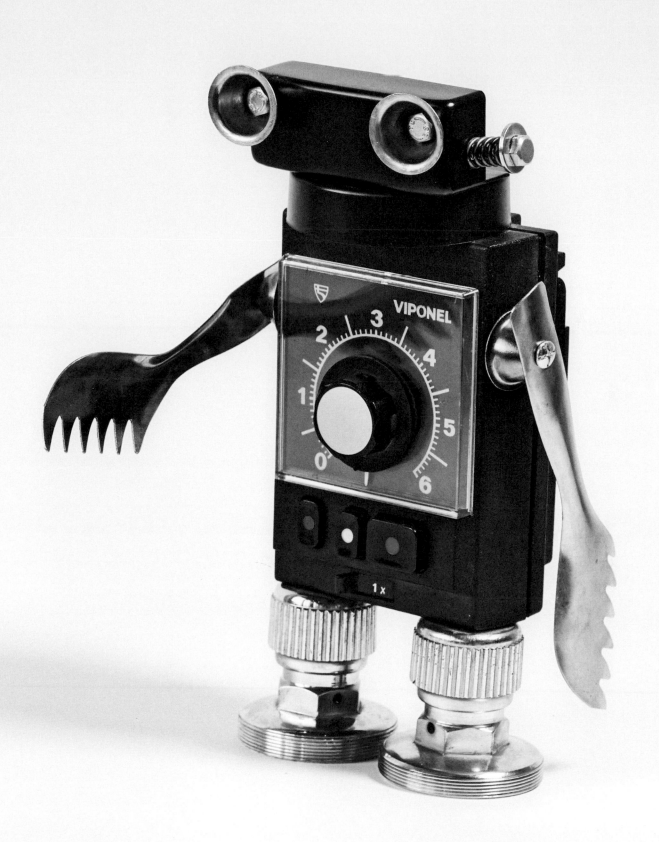

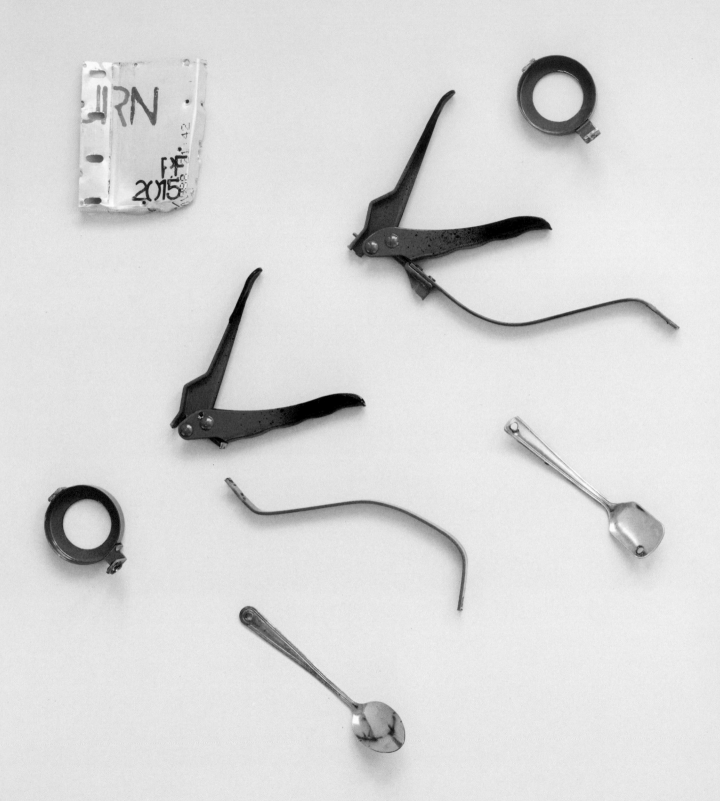

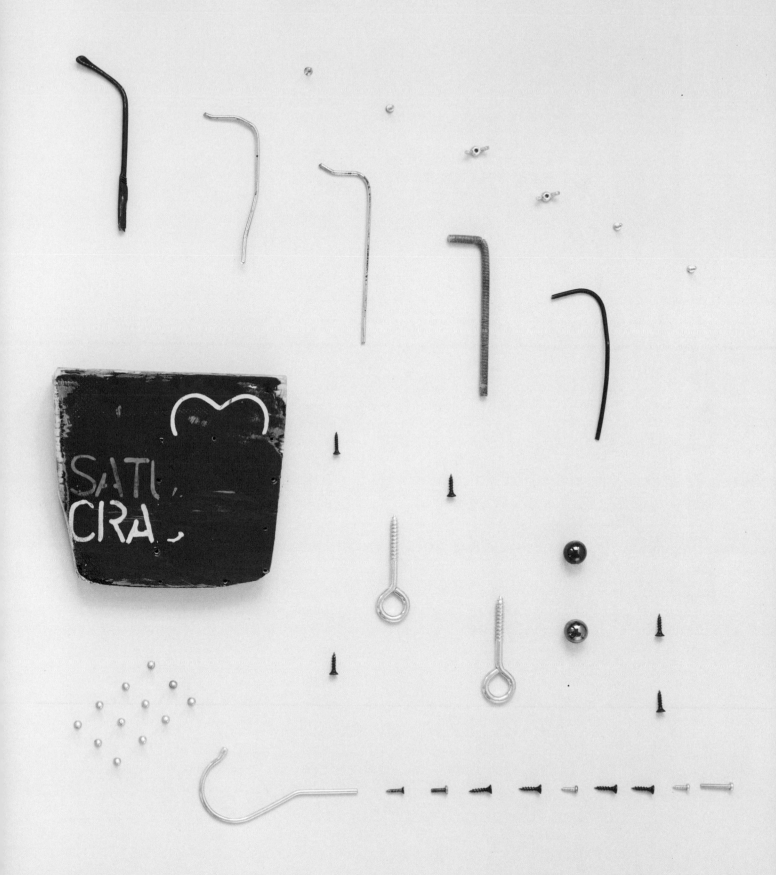

# SATURN CRAB

## STEFANO PILATO

**SIZE**
38 x 40 cm
(15 x 15¾ in)

**WEIGHT**
0.8 kg (1 lb 12 oz)

**COMPONENTS**
Scrap of wood from a
    kitchen cupboard

Scrap of aluminium
    (aluminum)

2 rings from an iron
    silicone gun

2 silicone-gun handles

2 thin strips of metal from
    a silicone gun case

2 hook eye screws

2 glass marbles

2 small bolts

2 wing nuts

3 small bent metal rods

1 coat hanger hook

1 iron Allen key

1 broken arm from pair of
    glasses

2 teaspoons

28 assorted small screws

**TOOLS**
Screwdriver
Drill
Glue

*I have been making sea creature sculptures for over 20 years and love to collect the main parts for my pieces from the beach. I match up small pieces of driftwood and other washed-up items with scraps of junk and odds and ends to bring new pieces into existence. Recycling is a core principle in my work and I'm happy to reuse unwanted useless things, reducing waste and making art for others to enjoy. Saturn Crab is one of several crabs I've made and his name is inspired by the red-orange piece of wood that forms his body, which reminded me of the red-orange of the planet Saturn.*

[ METHOD ]

First, gather all of your pieces and tools together, having already identified the items that will best make your crab work for you. Construction is relatively straightforward as all of the pieces are connected to the crab's body – eyes, claws and other legs.

Start by making the eyes. Glue the glass marbles into the two hook-eye screws and twist these into the top of the square wooden "body". You may need to drill a small pilot hole if the wood is hard. Then, take the iron rings and screw them into the top of the wood as well, just in front of the eyes, to complete the effect.

Next, assemble the front claws. For these, I used the "arms" of a silicone gun case, cut to length, but any thin strips of metal will do. Drill a small hole into each strip and into the silicone gun handles, and fix the strips to the handles with a nut and bolt. Wing nuts work well and look good for this purpose. Bend the strips a little and adjust the claws to give your crab extra character and screw them to the side of the body at the top.

Next, I fixed the square of scrap aluminium (aluminum) to the front of the crab with lots of small screws to add to its recycled aesthetic and keep it firmly in place. Then, take the spoons and other assorted items that make up your crab's legs, arrange them to your taste and use strong glue to stick them to the back of the block of wood. Add some paint effects if desired, and your charming sea creature is assembled!

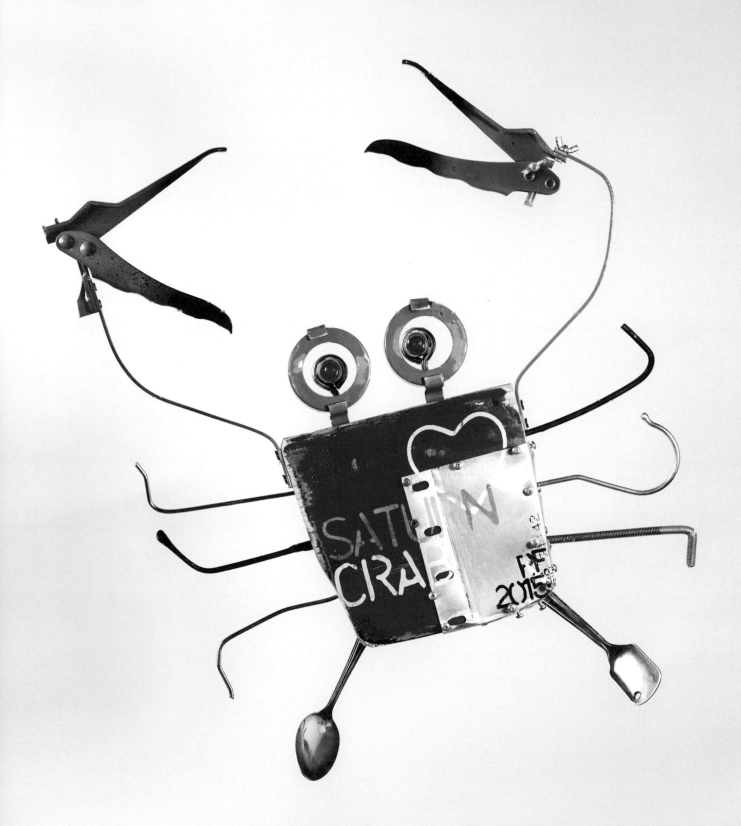

# GIRL ROBOT

## DAMON DRUMMOND

**SIZE**
52 x 20 cm
(20½ x 8 in)

**WEIGHT**
1.8 kg (4 lb)

**COMPONENTS**
1 vintage 1950s Christmas
tree stand part and base

1 vintage hand massager

2 vintage car windshield
wiper arms

3 assorted parts from
chrome light fittings

2 auto transmission parts

2 vintage casters from a
typewriter stand

1 flower from a vintage
brass chandelier
decoration

2 small electrical clamps

2 small metal spacers

**TOOLS**
MIG welder

Angle grinder

Drill

*I source my materials from local scrapyards as they seem to get a huge variety of great junk – from antique scrap to modern – come in every day. I like using vintage parts as much as possible because you just don't get the craftsmanship and design in newer parts. For Girl Robot, my starting point was part of a vintage Christmas tree stand that just looked more like a skirt to me. I then built up around that piece, using other found items, until the sculpture looked complete.*

## [ METHOD ]

To build *Girl Robot*, start by carefully laying out your found parts and "dry-fitting" them together so you are confident with the positioning of all the pieces. Clean and polish them, if you like, to give your finished piece a good shine.

Taking the vintage hand massager, dismantle it, remove any interior parts, and drill holes in the base and sides so you can attach the windshield wiper arms and the skirt. Fix these pieces to the body by welding, or using some suitably sized nuts and bolts if you prefer. Add the small electrical clamps to the ends of the arms and bring them together so they are touching and can hold the flower.

Next, make the head by piecing together two of the chrome light fittings and welding this to the top of the hand massager. Make sure you are happy with its angle before you do this. You want your robot to be looking wistfully at the flower held in her hands.

Then, move on to the legs. Drill holes in one end of each of the transmission parts so you can connect the typewriter casters for the feet, with a spot weld, if necessary. Next, weld the top of her legs to the inside of the skirt, using the metal spacers and/or one of the chrome light fittings for extra stability, if needed, and weld the bottom of her feet to the Christmas tree stand, which makes a good, stable base. The flower she is holding was added to her hands with a small tack weld. The assembly time for *Girl Robot* is around 6 hours.

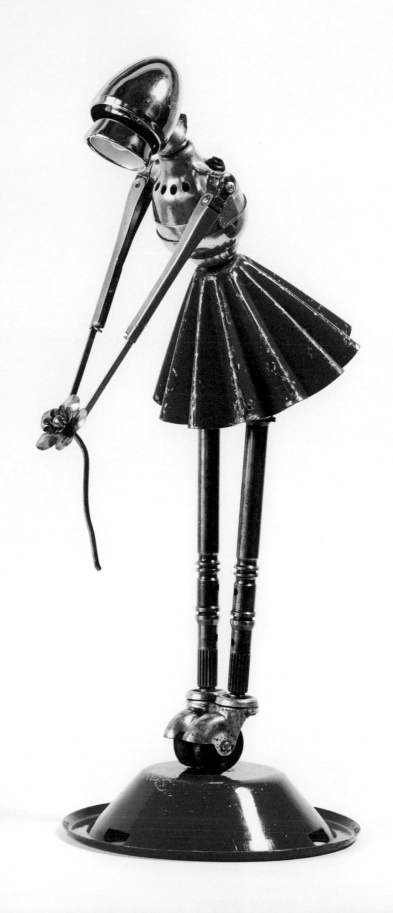

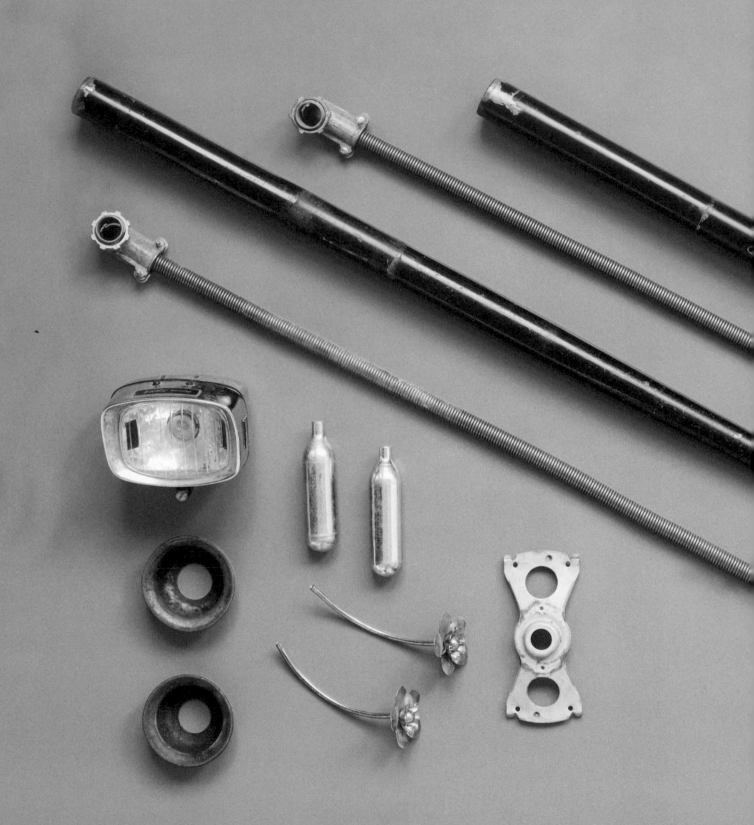

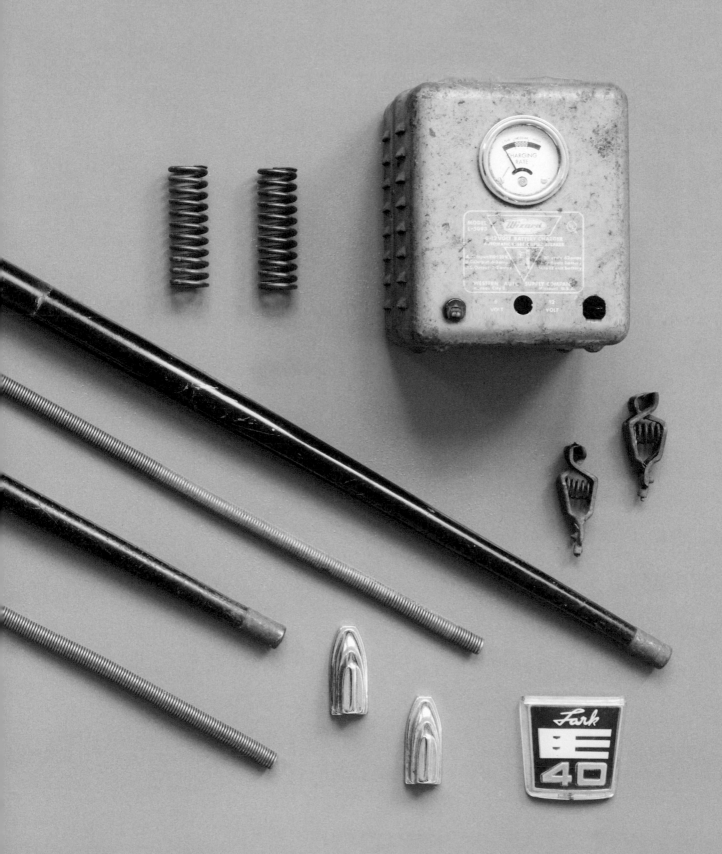

# EVEN ROBOTS GET THE BLUES

## DAMON DRUMMOND

**SIZE**
91 x 22.5 cm
(36 x 9 in)

**WEIGHT**
3.6 kg (8 lb)

**COMPONENTS**
2  1950s kitchen table legs

1 vintage battery charger

1 vintage bicycle headlight

2 long spring coils

2 small pieces of curved conduit

2 shorter springs

2 drum head lugs

2 small gas cartridges

1 Lark boat engine badge

2 small electrical clamps

2 large disc spacers (from farm machinery)

1 mounting bracket from an electric motor

2 vintage brass flowers

**TOOLS**
Metal punch

MIG welder

Angle grinder

Drill

Epoxy glue

*The inspiration for* Even Robots Get the Blues *came from a drawing in a vintage sci-fi book that showed a robot alone and bent over. To me, he just looked sad, and that gave me the idea to try to capture that feeling with some of the "junk" that I use for my sculptures. His story is that he has feelings for another robot and decided to take her flowers, but she is a fancy newer model and didn't want anything to do with an outdated and well-worn robot like himself. Her rejection is the reason he is in such a sad state.*

## [ METHOD ]

To make this robot, start with the vintage battery charger that forms his body. Take it apart and, using a metal punch and a block of wood, make rivet-like impressions all over it. Then fit it back together. Using the mounting bracket, attach the bicycle headlight to the top of the body to make the head. Angle it forwards for his downcast mood. Use spot welds for the fixings, or screws if you prefer.

Next, assemble the arms. Take the electrical clamps and tack weld one to one end of each of the long springs. Push the other end of each spring into a small piece of curved conduit and fix by tightening the conduit's existing fittings. Attach the other end of the conduit to a spacer, and then weld the spacers to the top of each side of the body. Then take the two gas cartridges and spot weld them to the back of your robot. This will help balance him when you attach the body to the legs.

Next, take the old table legs and cut them to your desired length. Weld some springs to the bottom ends of the legs, then, using an angle grinder, shape the ends of the legs so that they fit the shape of the drum head lugs, and then weld them to the lugs. Weld the other end of the legs to the bottom of the body, fixing the body at an angle so that the robot is slightly hunched over and taking care that he will be able to stand without toppling forward.

To finish, spot weld a flower to each hand, and fix a vintage badge to his chest with epoxy glue or a screw, as you prefer. Total assembly time is around 8 hours.

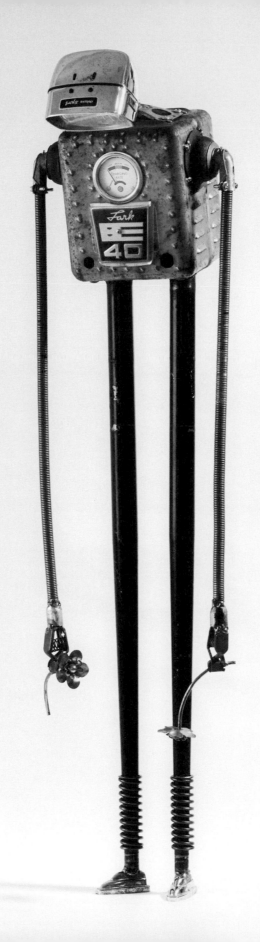

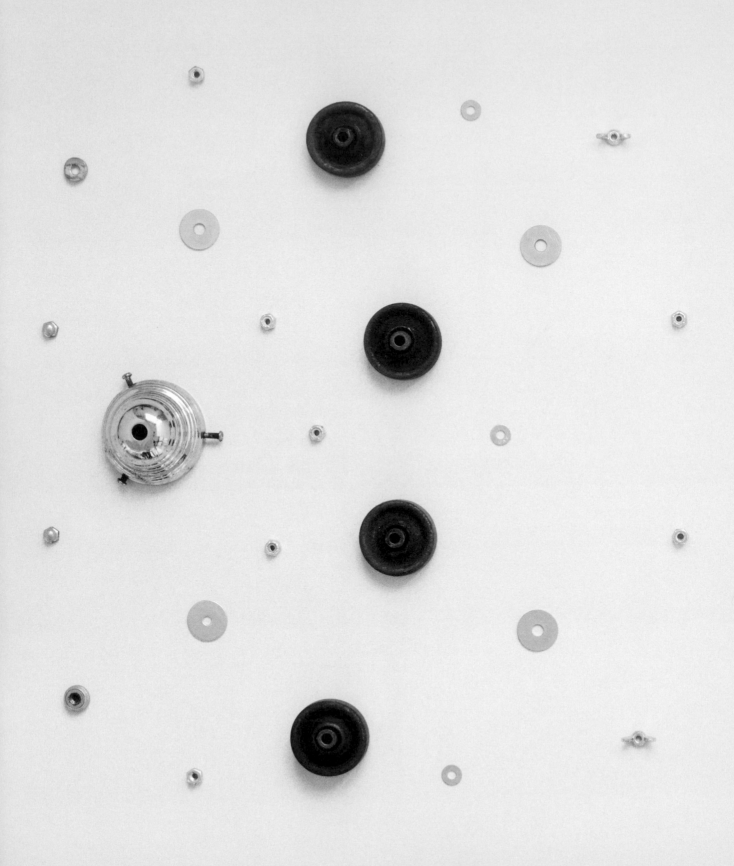

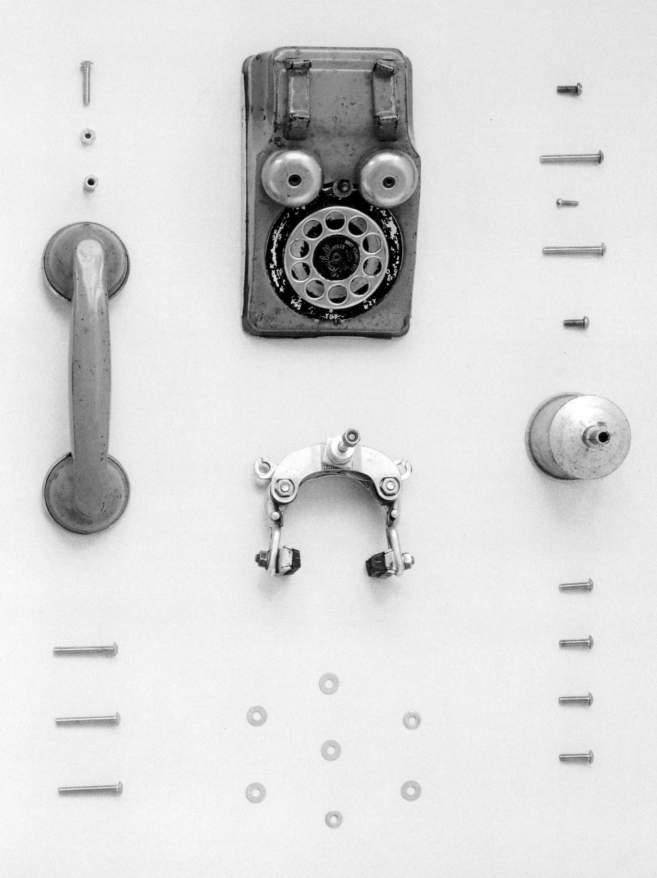

# MOBILE PHONE MAN

## PAUL LOUGHRIDGE

**SIZE**
30.5 x 13 cm
(12 x 5 in)

**WEIGHT**
1 kg (2 lb 3 oz)

**COMPONENTS**
1 broken 1950s tin toy
   rotary telephone

1 aluminium (aluminum)
   camp stove funnel

1 chrome lamp globe
   fixture

1 set bicycle caliper
   brakes, dismantled

4 roller skate wheels

2 wing nuts

2 brass cap nuts

14 assorted washers

13 assorted bolts and
   screws

11 assorted small nuts

**TOOLS**
Hacksaw

Hand files

Tin snips

Drill

Allen keys

Ratchet wrench

Socket wrench

*There was a time, not so long ago, when phones couldn't text, take pictures or GPS you to your next destination. It was a time when phones were simple and sturdy but painfully limited in their features. Progress was slow but there was one who believed in a better way, a smarter way, a mobile way.* Mobile Phone Man *was born! He didn't take too long to put together, either. I spent a pleasurable afternoon digging through bins, buckets and boxes in my workshop to find all the right pieces, and then a couple of hours assembling my little friend.*

### [ METHOD ]

To begin, lay out and clean all of your pieces and make sure all of your tools are to hand. Then, start with the head, which is made from an inverted old camp stove fuel funnel with a chrome lamp holder hat. If there isn't a hole in the back of the phone, drill one and slot in the funnel, fixing with nuts and bolts as necessary. Do the same for his hat. Use the steel wing nuts for ears and brass cap nuts for eyes, and the head of your bot is complete.

Next, work on the body. You'll need to fix the phone's receiver handle to the front of *Mobile Phone Man* with screws to stop it falling off when the phone is tipped up to form the body of your piece. Attach two of the roller skate wheels to the phone body to form shoulders, and two parts of the dismantled brakes to these to form the arms. Use more brake parts and the other two wheels to create the legs.

You can piece the limbs together rather like a Meccano set, using whatever suitable screws, nuts and bolts you have found, drilling holes into the different parts as appropriate, and stabilizing them all with a generous sprinkling of washers. You can make *Mobile Phone Man*'s limbs moveable, if you like, to give him adjustability, even more character and to enable him to sit down. This particular telephone even has a conveniently located hole in the bottom (the bot's back) so he can be easily hung on a wall, if that's where you'd like to keep him.

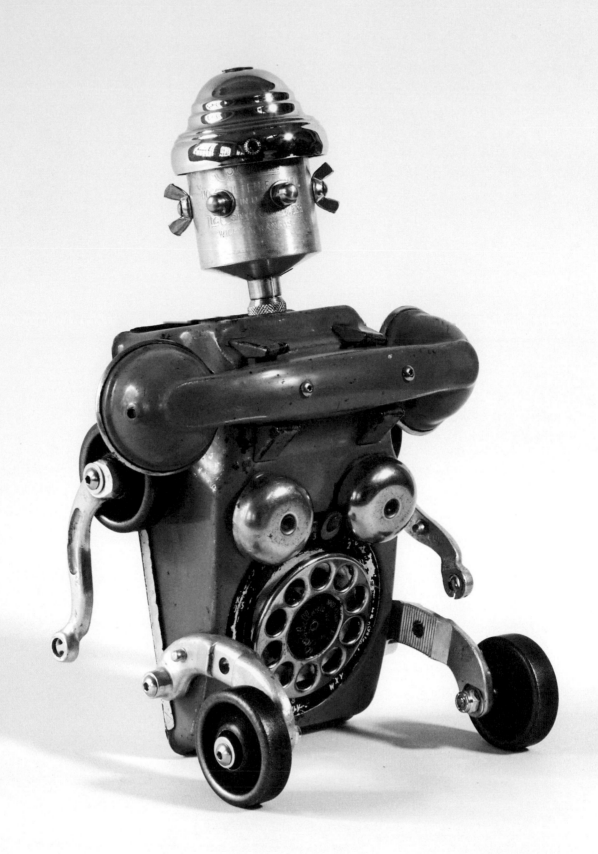

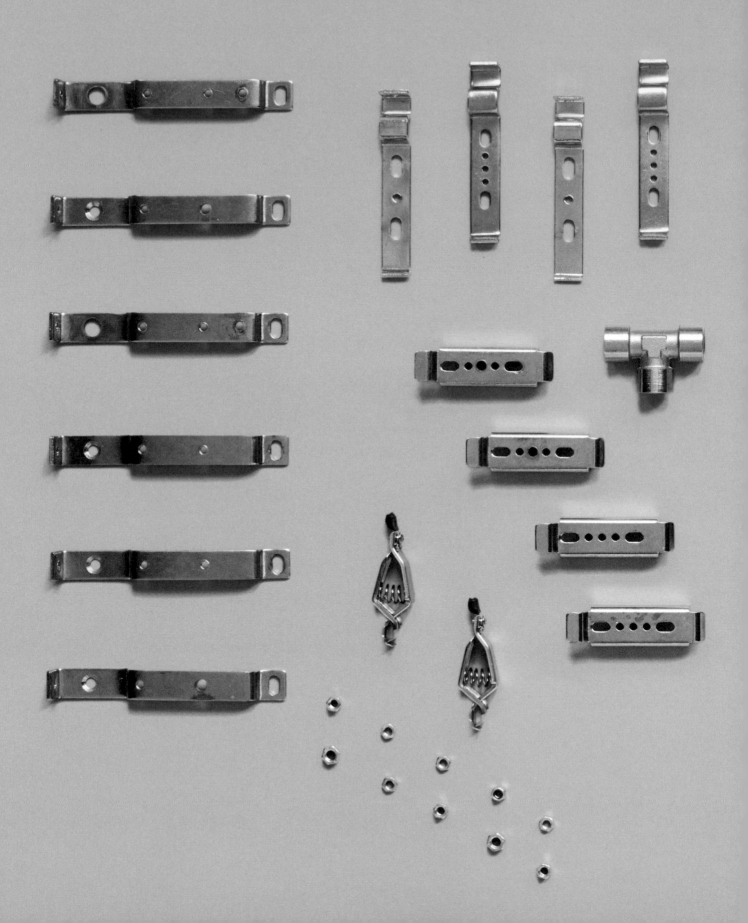

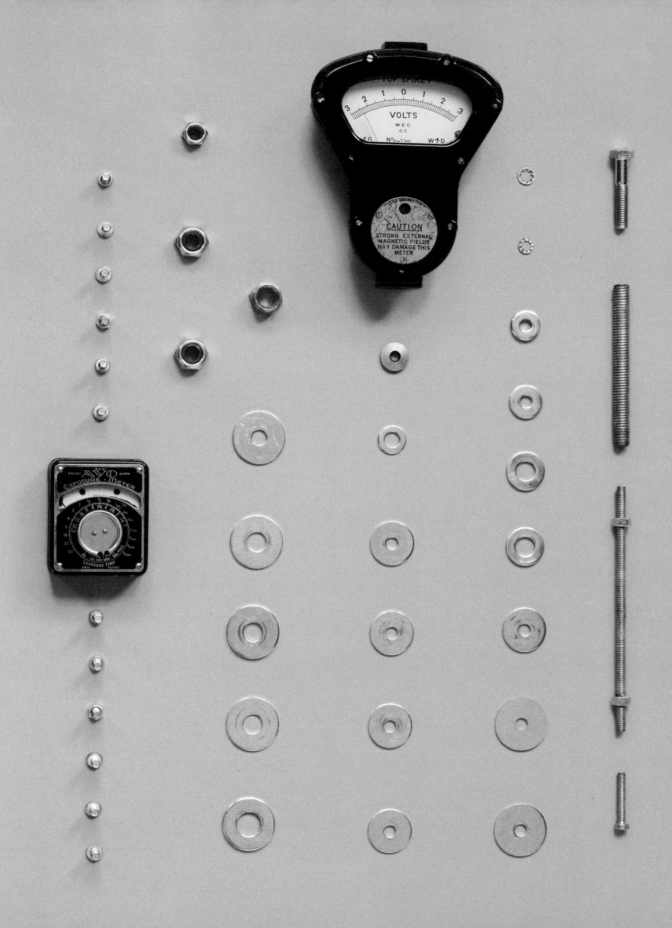

# MOON

## PAUL BRADY

**SIZE**
44 x 16 cm
(17½ x 6¼ in)

**WEIGHT**
1.4 kg (3 lb)

**COMPONENTS**
1 Bakelite volt meter

1 vintage light meter

14 assorted chrome-plated
kitchen brackets

2 battery charger clamps

1 chrome push-fit
T-shaped compression
joint

1 threaded bar

1 long bolt

Assorted nuts, bolts,
screws, washers and
rivets (about 12–20 of
each)

**TOOLS**
Drill

Wrench

*Moon is a rare robot. The idea for him came to me after I read about a boy who lived on the moon with his parents and had a robot dog as a friend. I then got to thinking about what sort of robot friend I would have, if I were ever to have one. So, this is my story of my robot friend Moon and how I made him... Moon is a tall robot with long arms and legs. His body is made from a vintage volt meter and some shiny new kitchen brackets and his head is a vintage light meter – a great find that instantly looked like his face to me. Assembly of a fairly intricate bot such as Moon can take me up to 4 weeks, which allows time to take it apart and start over if something doesn't look quite right.*

### [ METHOD ]

For the body, take one old Bakelite volt meter and clean it up – remove the front to do this, only replacing it at the end of the bot's construction. Drill a hole in each side of the meter at its widest point so you can attach the arms. Drill another hole top and bottom to attach the head and the legs. For the head, take the light meter, remove all of the non-essential parts, and drill a couple of holes in it for eyes.

Next, make the arms. Arrange some chrome-plated kitchen brackets to your liking and assemble them with two nuts and bolts for each arm and some washers to give him a round elbow joint. Fix a battery charger clamp to the bottom of each arm with some rivets to give a smooth look to the joint and some great robot hands. For the legs and feet, arrange the rest of the kitchen brackets as you'd like them and use nuts and bolts to join them together.

To assemble the whole robot, first take the T-shaped compression joint and fix it to the bottom of the volt meter with a bolt that passes through the tee and into the hole drilled previously. Place the legs in position at either end of the tee and secure with a rubber-backed washer and a locking nut, firmly tightened. Hold the arms in place using a threaded bar that runs through the back of the volt meter from shoulder to shoulder. A few washers will give a humanoid look of round shoulder joints. Fix the light meter head on the body with a simple bolt held in place with a rubber-backed washer and locking nut. Once this is all done, replace the front of the volt meter and your robot is alive!

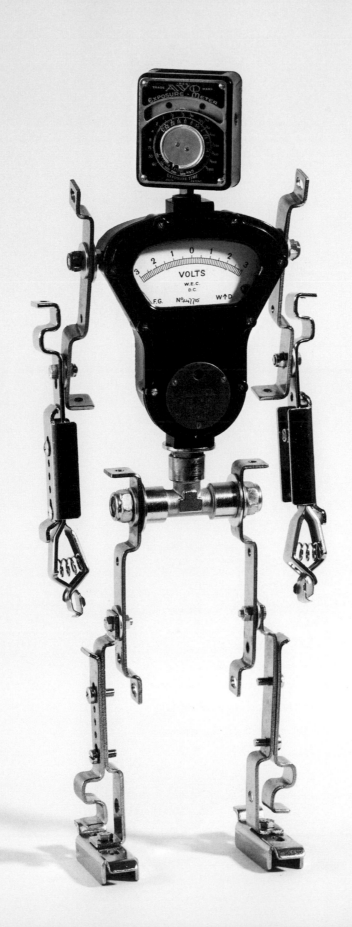

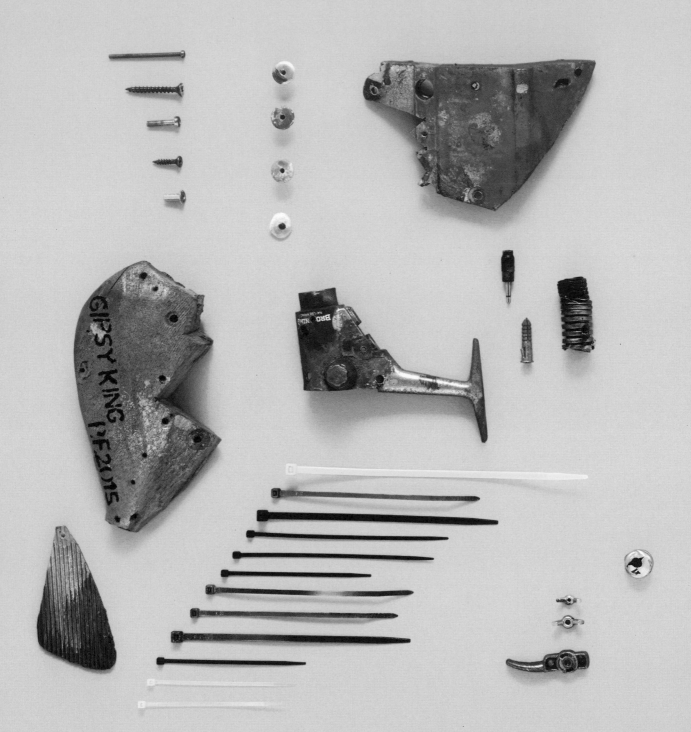

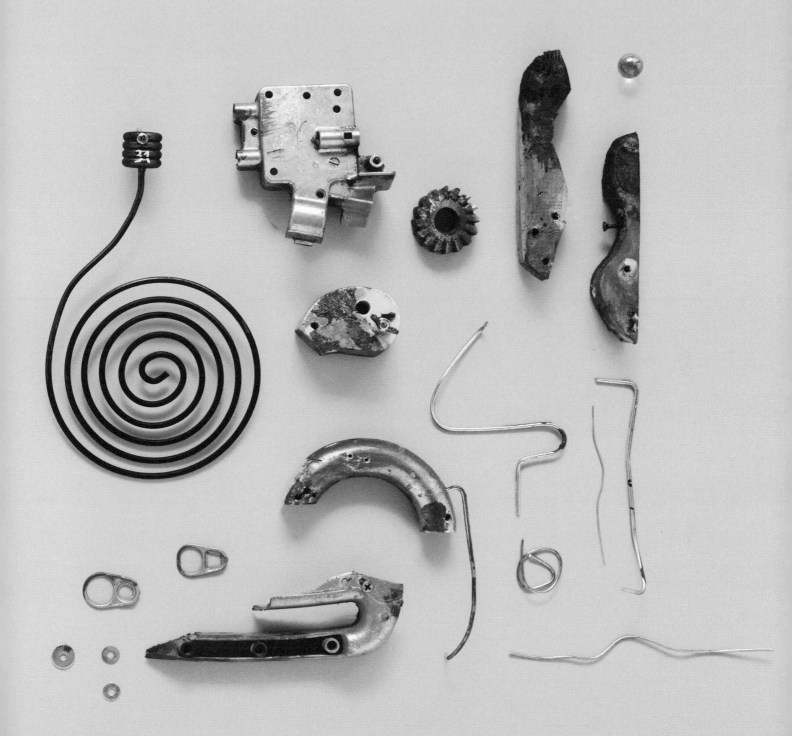

# GIPSY KING

## STEFANO PILATO

**SIZE**
68 x 35 cm
(27 x 13¾ in)

**WEIGHT**
3 kg (6 lb 10 oz)

**COMPONENTS**
4 pieces recycled wood
found on the beach

1 part of a lock

1 piece corrugated
cardboard

2 ring pull tabs

1 iron spiral

11 cable ties, varying
lengths

1 plastic dowel

1 steel gear wheel

1 glass marble

Part of an umbrella handle

Part of a fishing rod reel

Small piece of flexible
plastic tubing

Assorted screws, nuts,
bolts, rivets and washers

Assorted broken pieces of
scrap plastic

Copper wire

**TOOLS**
Screwdriver

Plane

Drill

Glue

*I found many of the pieces for* Gipsy King *washed up on the Etruscan beaches near my home in Tuscany, Italy. I like to make sea creatures from wood, plastic and other assorted debris that's been washed ashore, and* Gipsy King *is not my first seahorse. When creating him, however, I was inspired to try combining parts that seemed particularly unlikely to be joined together – this creative flexibility inspired the name* Gipsy King *because gipsy is a word I associate with freedom and improvisation.*

## [ METHOD ]

Gather together the assorted materials you have collected to make your seahorse. Note, this may take many months of searching, gathering and trying different combinations of found pieces. If possible, look along beaches and shorelines for suitable bits and pieces.

Combine these with other unwanted items from your own garage or toolshed, or everyday discarded scraps of junk, and you will soon have the pieces you need. Gradually connect them to each other, in a style of your choosing, using screws, rivets, wire and glue as appropriate. Add some paint effects if desired.

The assemblage and painting of *Gipsy King* took the better part of six days, but you can create your own seahorse in less time if you use fewer components and simple construction techniques. The trick is to find a piece, or pieces, that catch your eye and fire your imagination, and then play with them until they begin to form the creature you wish to make.

There is a certain irony in creating a beautiful piece from unwanted bits of junk that we have tossed in the ocean and it has returned to us. Enjoy breathing new life into old scrap, whichever creature you choose to make.

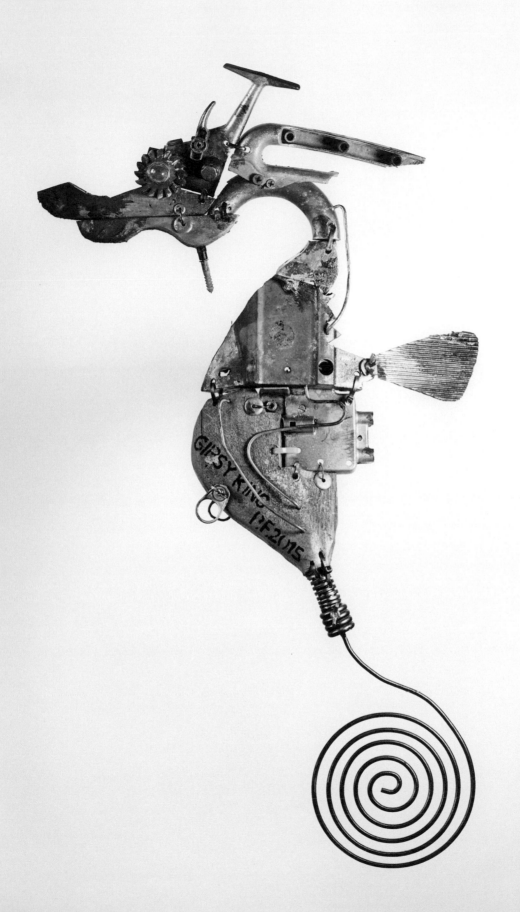

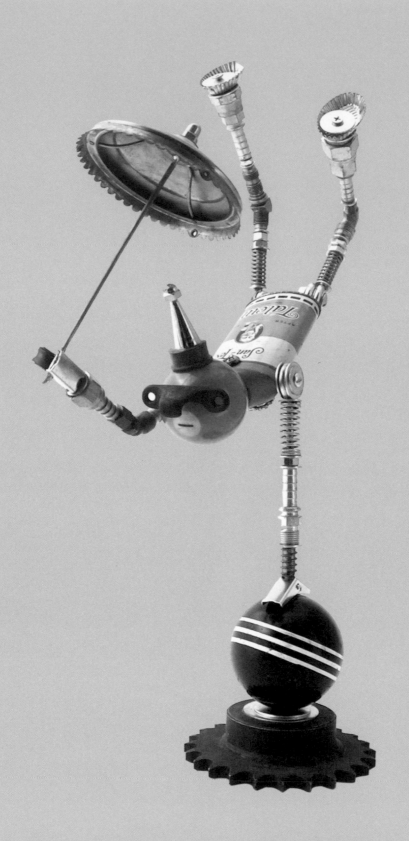

# INSPIRATIONS

## FROM AROUND THE WORLD

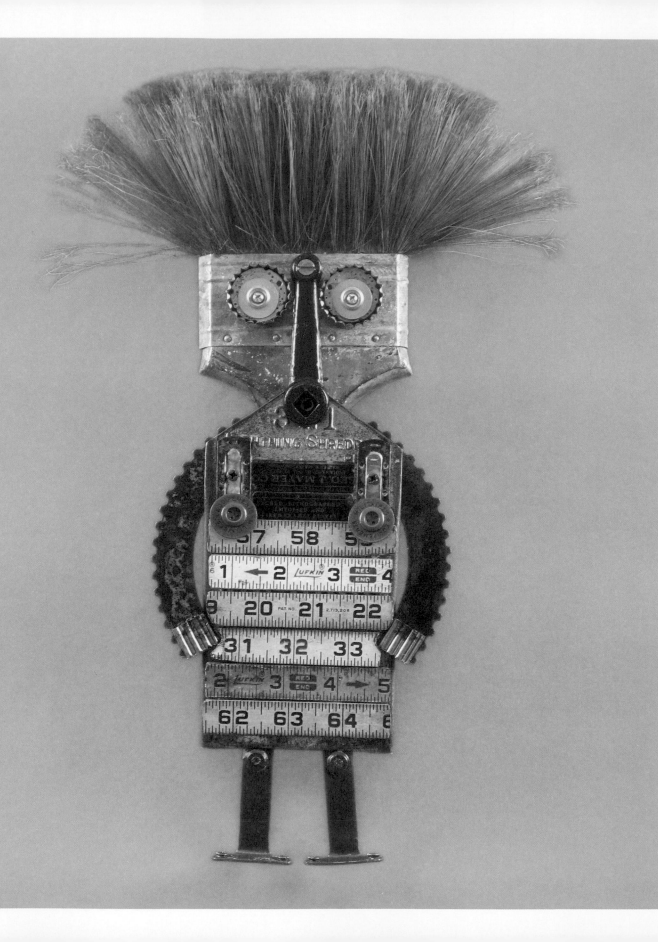

"For a hair-raising robot creation, try using an old paintbrush, like Donna Sophronia-Sims – the wooden handle provides a soft enough base for you to nail or screw on your other parts and the brush will add a bit of punk."

There are many more brilliant robot-makers assembling away in different parts of the world to create bots with a unique aesthetic and character. We have included a selection of our favourite pieces in this section to inspire you further to come up with your own ideas. There really are no limits to the kind of objects you can use to give your project a starting point – it's all about looking around, standing back, blurring your eyes a little and trying to see shapes beyond the original functionality of things: is this a vintage mixer or could it be a body with two legs sticking out? Is this a vegetable steamer or a skirt? Are these springs or perhaps locks of hair? Or you could turn the process around: is there anything in the shed that might make a good head of hair? Can I use an old paintbrush? It's a little bit like playing a game of free association – unlock your mind and let the objects you spot trigger a narrative.

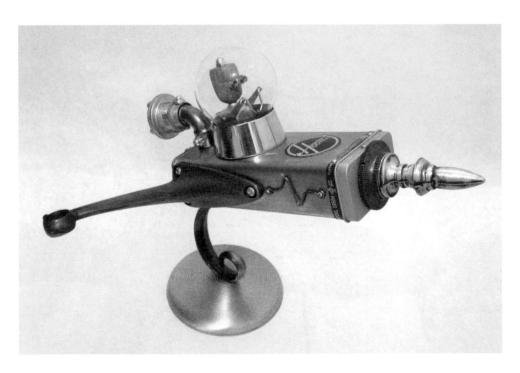

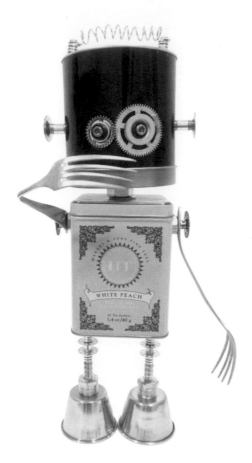

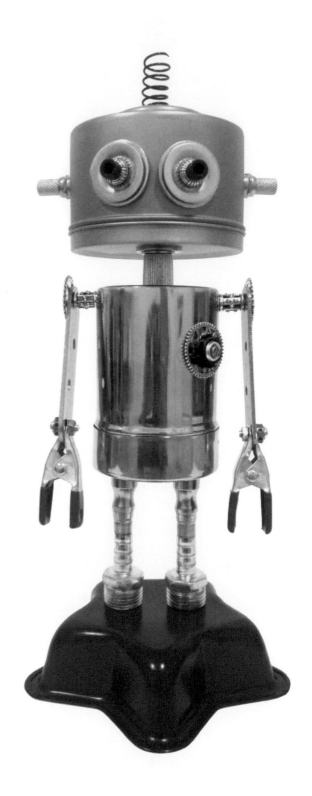

## deBOTed

Based in Barcelona, assemblage artist deBOTed uses all manner of unwanted materials to create his robots. Donations of broken or disused appliances are matched with miscellaneous flea-market finds to create charming pieces that he designs to pique curiosity and make people smile. While some pieces, such as *Tiny BOT* (right), are purely decorative, others have a practical use, such as *Robo-Combo* (above), which is also a storage box. Preferring manual assembly techniques to adhesives or welding, deBOTed believes that every found item has a value, no matter how broken or damaged, and can be repurposed to give it a second life.

## DONNA SOPHRONIA-SIMS

Donna Sophronia-Sims was inspired to make her quirky assemblage art after taking a metal-fabricating class. Based in Birmingham, Alabama, she enjoys the process of using found objects and discarded materials to create her assemblages and always endeavours to produce humorous and whimsical characters. Her pieces are primarily joined together using nuts, bolts, screws, rivets and adhesives. Steel objects are joined together with weld tacks, and Donna uses power tools for drilling or dismantling different parts. She finds parts for her pieces in antique markets, scrapyards and online. The little robots take on human, animal and sometimes otherworldly forms and Donna is influenced by folk art, characters and animals from movies and nature, and even by facial expressions and gestures that she sees in other people. *Lester* (see p124) is a wild-haired, overall-wearing character whose clothing was inspired by the US country TV show *Hee Haw*, while *Loki* (below, left) is a primate-like creature and *Maridell* (below, right) features a blouse made from a cookie cutter and a small strainer that makes a 1920s-style hat. Pages 128–129 show other examples of Donna's work: *Moose, Max, Norvell* and *Berta* (top row, left to right) and *Ozzy, Cleo, Patti Parrot* and *Bailey* (bottom row, left to right).

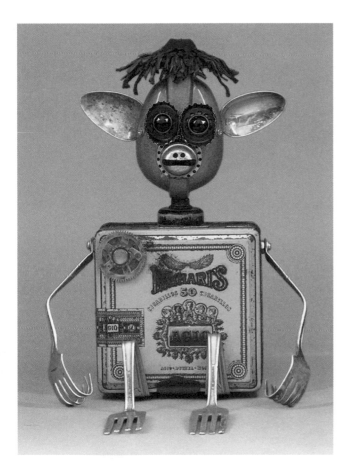

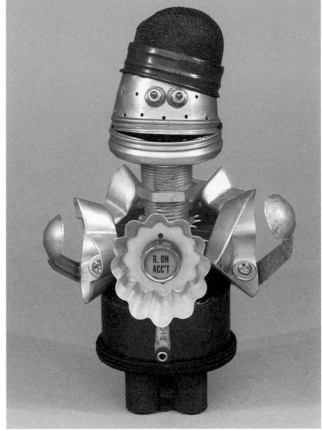

## AMY FLYNN

Combining her fascination with robots and her love of flea markets, Amy Flynn, from Raleigh, North Carolina, started making robots as a hobby. She creates her characterful FOBOTS® (Found Object Robots) from mostly vintage parts found at antique markets, flea markets, auctions and the internet, and likes to bolt and solder the pieces together. Each creation is unique and every one has a metal heart inside it, just like the Tin Man from *The Wizard of Oz*.

*Benny and the Jetpack* (right) was inspired by the propeller contraption on his back, made from a vintage hairdryer and old fan blade, with the little bird on the top either offering inspiration or else gently mocking Benny's misguided attempt to fly. Another of Amy's pieces, *Akimbo* (see p122), is a flexible, acrobatic little bot with posable arms and legs, which help create a sense of perfect equilibrium. His constituent parts include a pool ball, talcum powder tin, sash lock, sprocket wheel, candy tins and a cake-decorating nozzle.

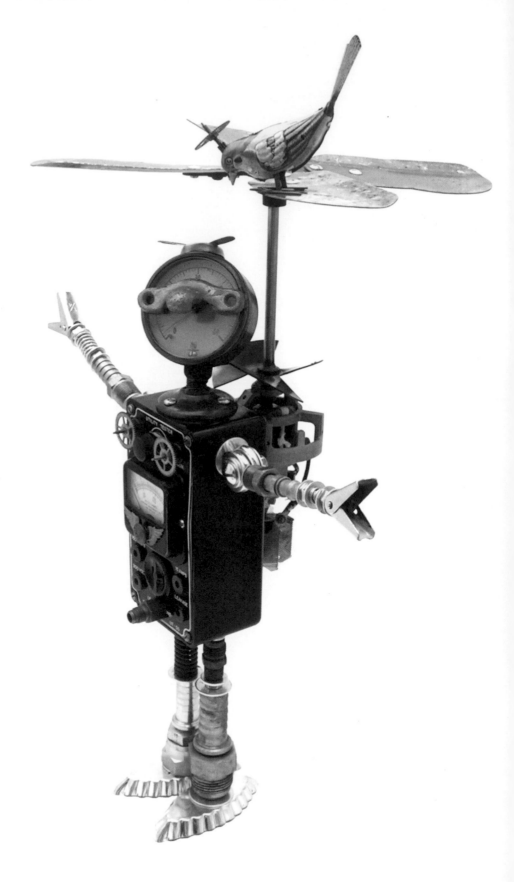

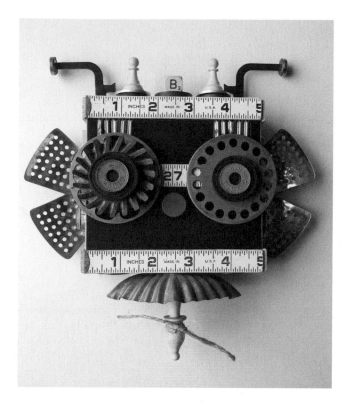

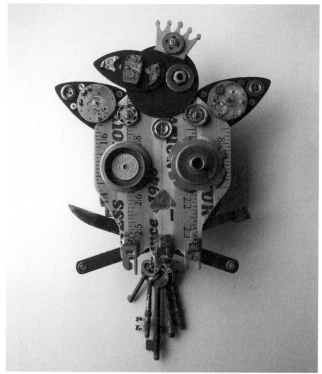

## JEN HARDWICK

An assemblage artist based in Seattle, Jen's assemblage work is most strongly influenced by the recycled materials she gets from garage sales and salvage yards. A rusted bit of steel might become a robot's arm or a bird's wing, and typewriter striker arms could be the snakes in Medusa's hair. *Bourdon Blanc* (White Bumblebee, above) is one of several bee pieces Jen has made, but is set apart by its simplicity. *Crow/Skull* (above, right) is a piece where the contrasting colours both separate and combine the two figures. The crow "crowns" the skull, and the skull becomes the crow's body. *Paper Owl* (right) was inspired by the drawer pulls filled with rolled-up paper maps, book pages and sheet music that make up his wings. Jen mostly glues or screws her found items together. She usually works on a base or panel and builds her pieces outwards from there.

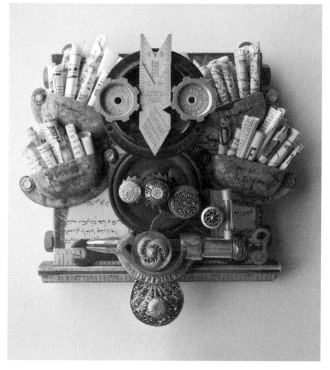

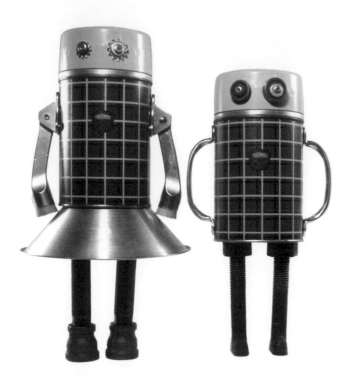

## NERDBOTS

Obsessed with all things robot, husband and wife team Nicholas and Angela Snyder from Kansas City, Missouri, decided some years ago to build a bot for themselves out of recycled materials. Since then, they have added many appealing geeky and playful robots to their collection. They find their parts in antique and second-hand (thrift) stores, scrapyards and estate sales where they search for discarded or unwanted objects that they can turn into something new again. They are inspired by the parts that they come across and can see a bit of personality coming to life in each item they pick out. Almost all of their robots are hand-assembled with nuts and bolts, although occasionally some are soldered or welded. Shown here, we have *Norma and Clarence* (above), *Gladys* (right), *Dot-Bar*, *Square D II*, *Rex* and *Bart* (opposite, clockwise from top left).

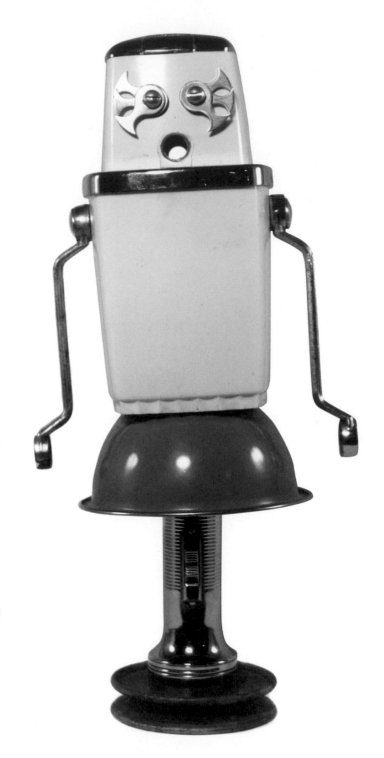

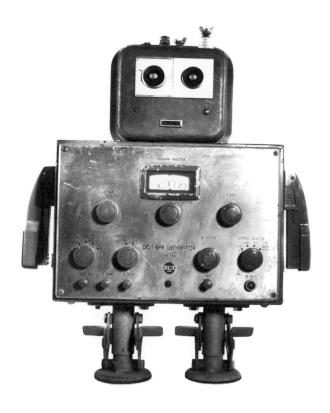

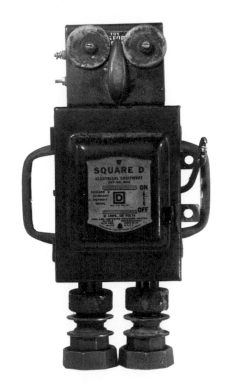

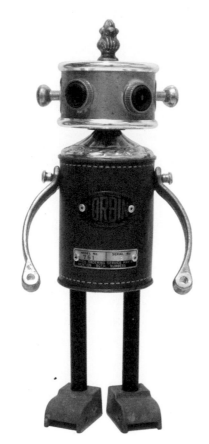
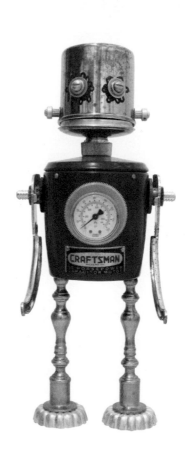

## DAN AUSTIN

Ottawa-based artist, Dan Austin, assembles his bots with nuts, bolts and rivets. He gathers parts from second-hand (thrift) stores and garage sales and gets his inspiration from the objects he finds. When naming his bots, Dan often uses the brand name stamped on one of their parts, or a nameplate from another object that fits their character. *Superior* (right) started with some vintage bathroom scales and, to Dan, is an old-school carnival barker asking ladies and gentlemen to step right up and guess their weight.

Opposite, clockwise from top left, are *Zenith*, *Frances*, *Craftsman* and *Corbin*. *Zenith* is built around a sturdy radio and is an older bot who enjoys puttering around his yard. *Frances* started with an upside down creamer, which looks like someone with their hands on their hips. She was inspired by a four-year-old girl Dan saw lecturing her younger brother. *Craftsman* began with the nameplate from an old motor. An efficient robot, he lives up to his name. *Corbin* was made around a vintage thermos with a faux leather finish and is just a guy out for a night on the town. *Hoover*, on page 125, is your typical teenage speed-demon, flying around the neighbourhood in his Jetson-style spaceship.

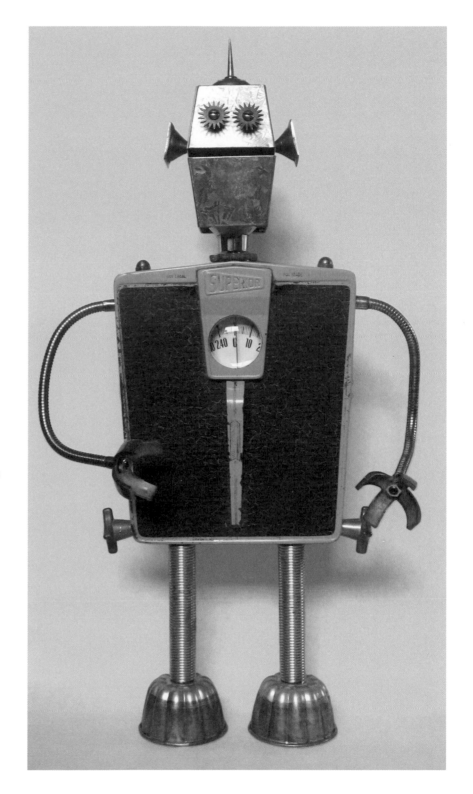

## JURRIËN VAN BERKUM

Based in the Netherlands, Jurriën van Berkum is a big fan of industrial design, and this, combined with a desire to recycle beautiful unwanted objects that would otherwise be discarded, led to the creation of his Alfabots collection of robots. Each unique bot takes either a humanoid or animal-like shape and they are all given a Dutch name, chosen by Jurriën to match his assessment of their character. He is drawn to parts that have an industrial or utilitarian aesthetic, and Jurriën assembles his pieces with clean connections – using only nuts, bolts and screws – so that he can fix them together or take them apart easily.

*Femke* (opposite, top left) is a female bot with metal tubing arms in a vivid purple, which are attached to a thermos-lid body above a stylish vegetable steam-rack skirt. Jurriën was inspired to make her after spotting her skirt at a second-hand market and thinking it was the perfect piece of clothing. With springs for legs and stainless steel egg-cup feet she is a bold but classy character. *Charlie* (opposite, bottom left) is a happy but slightly naive little dog who thinks she's bigger than she is. Her head came together way before her box-camera-based body, but once Jurriën added her legs (made from dismantled hand brakes) and tail he was delighted with how anatomically correct she looks. The main body of *Bert* (opposite, right) was lying around Jurriën's workspace for a long time before he found the right body parts to match the heavy military communications box. Eventually, he found the bright blue metal arms and loved the colours when he attached them. Strong but beautiful, they aptly reflect Bert's character – a little intense, but friendly and open-minded.

## MATTHEW ROBY

British artist Matthew Roby finds the parts for his robotic sculptures mostly from repair shops, old factories and house clearances. Inspiration for a piece may come from researching an idea for a character or from a found object, which can inform the development of the whole piece. He usually welds or solders key joints and sections together and then uses whichever combination of drills, saws, screwdrivers, rivets, glues, nuts and bolts are required. *Slow Coach* (right) came to life after an old speaker of Matthew's blew up. The speaker's shape and colour had similar qualities to a section of shell, so he sourced more from a music store and assembled the full shell before adding iron vice stands for legs and a rusty switch box for his head.

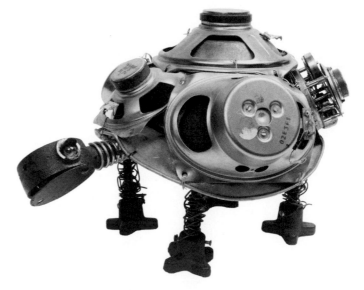

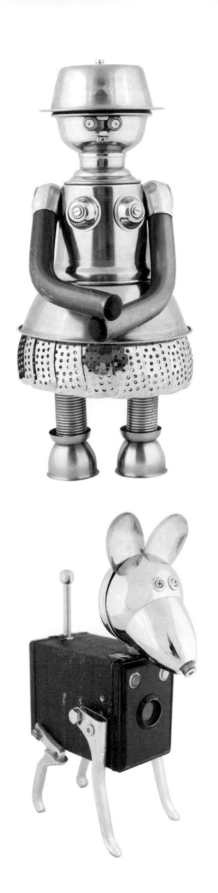
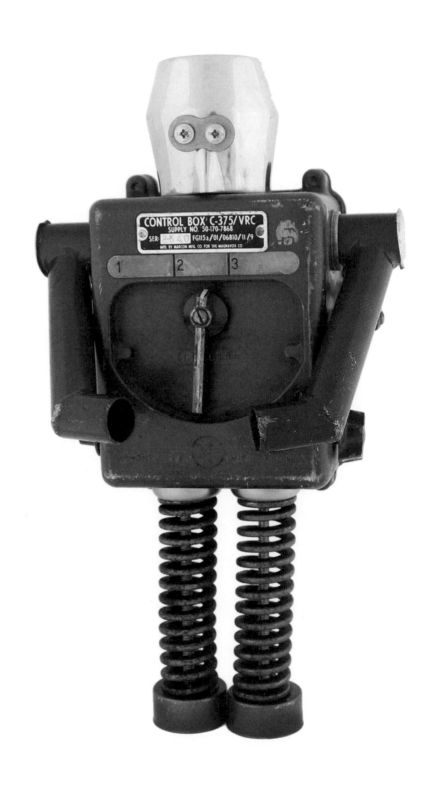

# ACKNOWLEDGEMENTS

Firstly, a huge thank you to all the wonderful robot-makers who collaborated with us in the making of this book – your beautiful creations and sense of humour have brought so many smiles to so many people. Secondly, a big, big thank you to our brilliant *Assembled* team for their undying enthusiasm and commitment to the project: Sarah Smithies, our researcher; Becky Miles, our project editor; Manisha Patel, our designer; Brent Darby, our photographer; and our editorial interns, Harriet Webster, Niki Mehta and Katie Lawrence. Below is a little more information about each of the *Assembled* artists, in their own words.

**DAN AUSTIN** I'm a born tinkerer and junk addict and am never happier than when scouring the trash, thrift stores and scrapyards for parts for my robots. As a child in Canada, I was raised on a steady diet of comics, sci-fi and Saturday morning cartoons. I took it for granted that when I got older the world would be populated by Jetson-style robots, happily doing the drudge work that we have no desire to do. With my robots, I try to create what should have been – artifacts from our promised future. www.flickr.com/rivethead-robotics

**JURRIËN VAN BERKUM** I was born in 1976 in the Netherlands and attended art school before going on to become a graphic designer. I have always loved industrial design and didn't want to spend my life only designing on a screen. I wanted to start making things with my hands again. Also, there are too many beautiful materials being thrown away because they are no longer thought to be useful – my wish to recycle these things and to design and build my own droids led to the creation of my Alfabots. www.alfabot.nl

**SCOTT GEOFFREY BLOOD** When I first started making assemblage sculptures I soon ran out of storage room for all the interesting objects I was collecting, many of which I knew would never get used. What I needed was a basic form made from readily available parts that I could repeat, modify and build upon – and the three pieces in this book reflect this. There are always plenty of old golf clubs, spoons or kettles to be found. I still enjoy experimenting – for example, making a life-sized man entirely from angle-poise lamps – but always with this repeatable foundation in mind. I encourage anyone to try it. Inspiration is all around us. www.sgbcreative.co.uk

**PAUL BRADY** As a child growing up in the 1960s, I loved comics such as *Dan Dare* and *The Rocketeer*. Our TV shows were also full of sci-fi heroes fighting robots from far-off galaxies and, having been inspired by these and the stories of Isaac Asimov, I built a robot based on Asimov's story Robot AL-76 Goes Astray. This retro robot sculpture has become the inspiration for many of my robots. Right now, I am excited about steampunk and its association with Victorian explorers and inventors. As a result, many of my robots are now more than just sculptures – they are also functioning lights for the home. www.pbretrobots.com

**DAMON DRUMMOND** I was born in the 1960s, in Akron, Ohio, and grew up in an artistic household. As a child, I was always drawing or taking things apart to see how they worked and which parts could be used for something else. I always saw discarded items not as trash, but as opportunities to create something new. In the late 1980s, I bought a welder and began experimenting with sculpture. My pieces reflect my personality and the things that I love, such as vintage objects of all descriptions – especially sci-fi – hot rods and motorcycles. www.realgonedaddy.com

**AMY FLYNN** I'm an artist from Raleigh, North Carolina, and Fobots® (Found Object Robots) are my creations. After more than 25 years as an illustrator, I started making robots in my spare time. Now it's my passion, as it combines my two favourite things – making art and shopping. I love to hunt around for cool, vintage stuff to create unique creatures, full of personality. They all have fun names (*Roboticelli*, *Sigmund Droid* and *Queen Elizabot*, to name a few), a copper number

tag on their butt and a hidden metal heart inside. I now make and sell my Fobots full time and am so much happier than I ever was as an illustrator. www.ifobot.com

**JEN HARDWICK** I'm a self-taught artist and art has been a part of my life for as long as I can recall. I always used to consider myself a painter, but assemblage art feels much more natural to me now and I love to work in this medium. I pull ideas from every aspect of my life, but the strongest influences come from the recycled materials themselves. A shape, a colour, or just the speckles of patina can be the trigger for an entire piece. I love sensing the age and history of materials that have moved through time and space to end up in one of my pieces, and I love breathing new life into things that have been discarded and forgotten. www.jen-hardwick.com

**AMY KNUTSON** I began working on my androids in 2015, after seeing a dog made from an old lunchbox online. My husband encouraged me by opening up his workshop, tools and collection of hardware miscellany. He taught me a lot about assembly and helps with any construction problems that come up. I also find pieces at thrift shops, garage sales and antique stores. I've even found them on the beach and alongside the road – I see body parts everywhere! The inspiration for a droid usually comes from a specific part. I see a fairy's skirt or dog ears and start figuring out the rest. Pieces can sit on the "ideas" bench for months while I try different things out. Then, one day, it all falls into place, and is done. However, nothing is finished until it makes me laugh. www.etsy.com/shop/vintageandroidart

**PAUL LOUGHRIDGE** Some of my fondest memories are of me and my brothers tearing our toys and bikes apart just so we could figure out how things worked. Then, armed with youthful confidence and my dad's tools, we set about creating a "better product". Now, working out of my "lab" in Northern California, I transform what most people would consider junk into one-of-a-kind, cyber/steampunk-style assemblage sculptures. During the creative journey, I develop a unique character and personality for each piece, often injecting some humour. My pieces are generally influenced by my solid childhood diet of space and sci-fi movies and TV shows and I stock my lab with parts found at flea markets, garage sales and old warehouses. www.flickr.com/photos/lockwasher

**DAVID MEAD** I was at an art and craft show a few years ago and wandered into a booth filled with wildly imaginative assemblage creatures. I immediately imagined my own childhood bedroom filled with robotic creatures that had assembled themselves from objects around the house. From that day, my eyes were opened to the faces and features that are so obviously designed into everyday mid-century household items. I love hunting for interesting vintage kitchen pieces to make my kitschy robots. I rarely have an idea for a piece in mind when I go to an antique market or flea market. I just let the personalities speak to me. www.etsy.com/shop/kitchybots

**BRANIMIR MISIC** I am a mechanical engineer by training and have always been interested in how objects are assembled and how they work. I started making sculptures from recycled metal in 2011, and source materials for my pieces primarily from antique markets, to give them a more authentic character and history. Most of my pieces have humanoid characteristics, and are built to evoke amusement. My pieces are generally under a cubic metre in size and are usually exhibited at art shows, on Etsy and on DeviantArt. www.etsy.com/shop/BranMixArt www.creationeuropeenne.deviantart.com

**STEFANO PILATO** I live in Tuscany where I work as a visual artist. In 1993, I started production of my "Pesce Fresco" ("Fresh Fish") assemblage pieces. I comb the Etruscan beaches near my home, collecting things that the sea brings back to the land, which I combine with various other discarded materials to create my fish-themed sculptures. I consider myself lucky to be in a profession that I enjoy so much. Since 1999, I have also collaborated with the Department of Mental Health in Livorno, Italy, directing visual communication and painting workshops for psychiatric patients, and training workshops for students and mental health professionals. www.artpescefresco.com

**JAVIER ARCOS PITARQUE** As a child growing up in Ecuador, I loved robots and was particularly captivated by the US TV series *Lost in Space*, where one of the main characters had a robot friend. As an adult working in the advertising industry in Madrid, Spain, I began collecting tin robots but soon decided to create my own. I find parts in the flea markets, hardware stores and antique markets of the cities

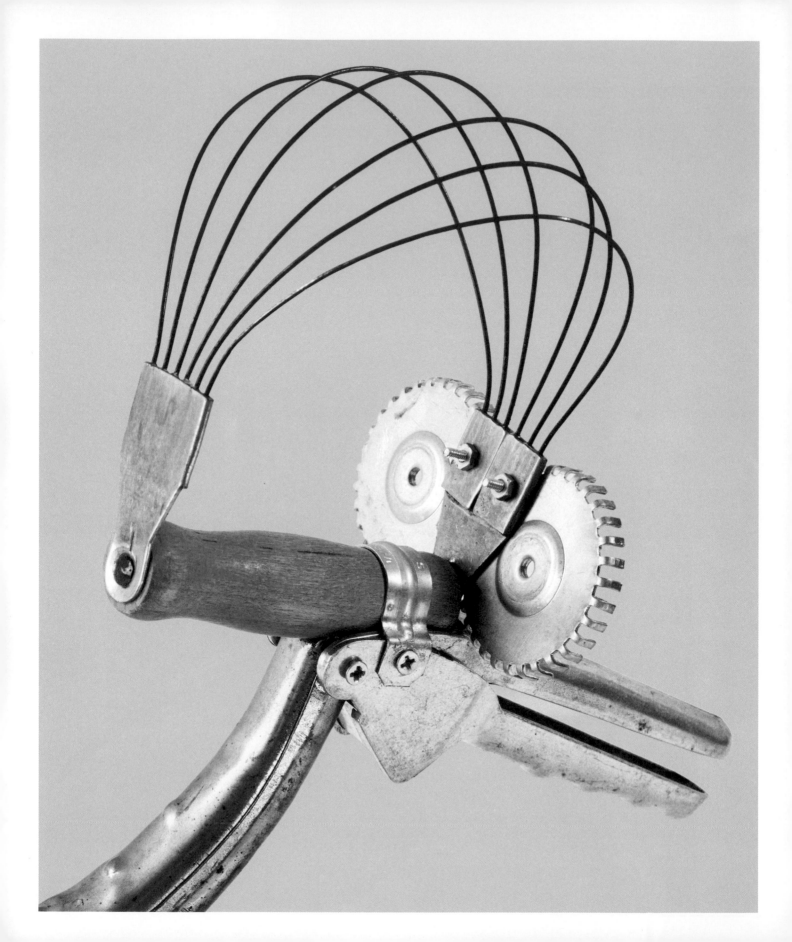

that I visit all over Europe. I'm also a fan of vintage branded packaging and many of my bots feature a branded tin as their "body". There is no special secret to their construction, just time, patience, imagination and creativity. www.pitarquerobots.es

**MATTHEW ROBY** My three-dimensional work features anthropomorphic steampunk-style characters influenced by pop culture, animals and real-life observations. Each piece has a strange story of some kind to tell, often sprinkled with dark humour and pathos. I like to recycle domestic or industrial materials into my robotic sculptures as a subtle comment on technology, disposability and the speed in which once-admired devices become obsolete. I strive to reach a point where reality and make-believe merge, taking familiar creatures and giving them distinct and extraordinary personalities. www.artfinder.com/matthew-roby

**GILLE MONTE RUICI** I'm a French artist, based in Paris, who makes robots from old metal objects that I find in second-hand stores, lying around in the street or even in the trash. I like to give a second life to discarded items and one that's quite different to their first existence. Generally, I don't go looking for parts with an idea of a finished robot in mind – I use my visual instinct and let the pieces I find suggest ideas to me. I sell my creations from time to time – at art fairs and galleries in France and Belgium – because they won't all fit in my house! www.flickr.com/gille-monte-ruici

**DONNA SOPHRONIA-SIMS** The pursuit of humour and whimsy was what started me wanting to create my quirky robots. I use old, damaged, rusty and recycled objects made of metal, wood, plastic or fabric and tinker with them, trying out different arrangements, until my intuition tells me it's

right. During this process I consider basic design principles such as colour, balance, size and scale and harmony. It's fun and challenging to figure out the best way to join all the pieces together. Sometimes it's simple and sometimes complex. By focusing on ordinary objects I give the observer another view of how these objects can be used to create a work of art. www.castofcharacters23.etsy.com

**DEBOTED** I started deBOTed in Barcelona, Spain, in 2012. Since then, I have produced more than 300 unique robots that are now scattered all around the world. The name "deBOTed" comes from a fusion of the words "devotion" and "robot", and represents my passion for robots from old B-movies, the 1980s manga films of Go Nagai, and robot toys manufactured between the 1960s and 1980s. Under this name, I make bots from recycled parts, found objects and everyday materials, using manual assemblage techniques. I love creating artistic pieces with parts of diverse origin that have no apparent use, and I hope my robots transmit something of this passion to their new owners. www.facebook.com/deBOTedrobot

**NERDBOTS** We are Nicholas and Angela Snyder from Kansas City, Missouri, and we love anything and everything to do with robots. After deciding to build our first robot on a whim, we have now added many fabulously geeky robots to our collection. We spend our free time trolling junk stores and scrapyards looking for the most interesting robot parts we can find. On their own, each of these parts seems unwanted or out-of-date. But, as we assemble them in our workshop, they take on an endearing quality, coming together to make something treasured again. www.nerdbots.net

The publisher would like to thank the following for their kind permission to reproduce their photographs:

Page 11: Getty Images / Moment Open / SPL; Page 12: Getty Images / E+ / alvarez; Page 14: Getty Images / Moment / Busà Photography; Pages 80–81, 84–85, 102–103 & 118–119: Photographed by Ania Wawrzkowicz and styled by Aliki Kirmitsi; Page 122: Fobots / Amy Flynn; Page 124: Cast of Characters / Donna Sophronia-Sims; Page 125: Rivethead Robotics / Dan Austin; Page 126: deBOTed / Albert G; Page 127–129: Cast of Characters / Donna Sophronia-Sims; Page 130: Fobots / Amy Flynn; Page 131: Jen Hardwick; Page 132–133: Nerdbots / Nicholas & Angela Snyder; Page 134–135: Rivethead Robotics / Dan Austin; Page 136: Matthew Roby; Page 137: Alfabots / Jurriën van Berkum.

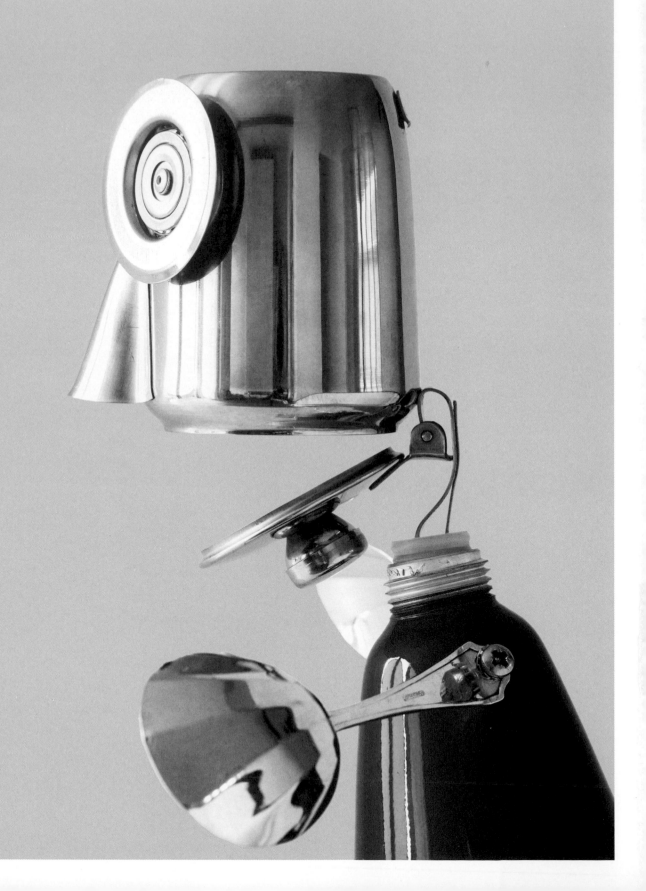